D0502487

BARRON'S ART HANDBOOKS

DRAWING

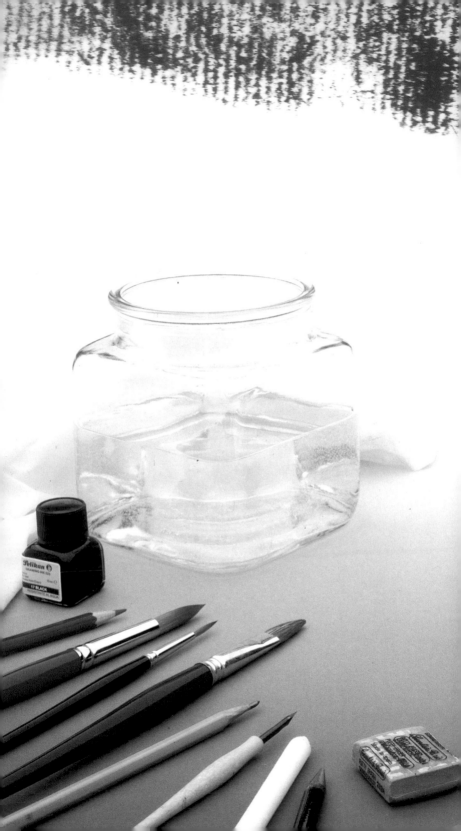

BARRON'S ART HANDBOOKS

DRAWING

BARRON'S

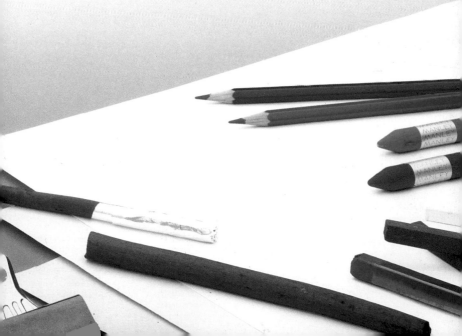

CONTENTS

5

CONTENTS

THE THEME OF A DRAWING

Drawing is the foundation of all artistic expression. Whether it be painting, sculpture, architecture, or often even cinema and photography, the initial idea will be set out in a drawing of some kind. Furthermore, the universal nature of this artistic medium allows it to be adapted to any genre in various ways, either as an art form in itself or as a study or an intermediate step to understanding a certain subject.

A selection of basic drawing tools.

Drawing Materials: Simple but Varied

Drawing is an art that is as complex as painting, music, or dancing; there are as many types of drawing as there are pictorial styles and techniques. Although we could spend thousands of pages examining techniques, tools, and materials, you only really require paper and pencil to draw something. In fact, with these two humble objects and our creativity there are infinitive possibilities of what we can achieve. In addition to the pencil and paper there is a wide range of other drawing materials, each of which

There are many types of paper.

has its own techniques and produces its own particular effects. Among the most common drawing tools are pencils, graphite sticks, charcoal, charcoal pencils, chalk, Conté, stumping pencils, erasers, ink, felt pens, and pastels. Furthermore, each medium requires its own particular paper. Paper comes in a wide variety of types according to weight, color, and material, and is available in a variety of sketch pads, blocks, or in separate sheets.

Still Lifes

A still life is an excellent subject for studying the composition of a painting. A drawing may either be a preparatory sketch for a more intricate work or a finished work of art. A still life can be tackled in many ways, but is usually used to learn how to represent objects in reality. The preliminary drawing establishes the main features of a still life, which are the division of space and the composition of forms, while taking into account the proportions of the different objects in relation to one another and their surrounding spaces. Another aspect of still life drawing is the way in which textures appear under

Any subject can be used in a still life. This picture was drawn with a lead pencil on medium-texture paper.

A still life allows us to study not only forms; we can also draw plants, fruit, and so forth. This picture was drawn with blue chalk on medium-texture paper.

different lighting conditions.

Landscapes

The themes of the urban or the rural landscape or the seascape can be developed as much as imagination permits. Landscapes can include ruins, cities, villages, and so on. Furthermore, mountains, skies, sea and beaches are quite

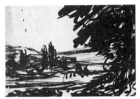

Alexander Cozens, Composition for a Landscape. *Drawing executed with brush and China ink.*

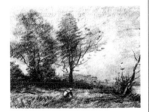

Corot, Landscape. *Drawn in charcoal.*

often found represented in landscapes.

Portraits

Portraits are one of the most complicated genres, yet among the most studied by artists of all eras. In addition to trying to obtain a likeness of your model, the mono-chromatic nature of drawing allows the expression of the personality of the subject being drawn. Each method of drawing has a distinct method of expression, but there are certain aspects of portrait

MORE INFORMATION
- Landscapes and sketching **p. 46**
- A portrait in Conté and charcoal **p. 78**
- The nude **p. 90**

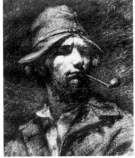

Courbet, Man with a Pipe. *Drawing in charcoal.*

drawing that the artist should know, such as the study of features, proportions, and the varying effects of light on skin.

Figures

Figure drawing is a broad specialty that includes a range of subthemes. The field of figure drawing consists of the representation of humans as well as of animals. Within the human figure theme we should stress the importance of studying the nude, since, due to the anatomical complexity and the evaluation of light and shadows, if you know how to draw a good nude you can

Delacroix, Study of a Detail of the Death of Sardanapalus. *Drawing executed in pastel on colored paper.*

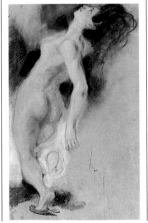

The Limits of a Drawing

The first stage of a drawing consists of applying several basic lines in order to situate and depict the subject matter. However, sometimes a drawing gradually distances itself from its initial concept and undergoes a radical transformation from drawing to painting. Such is the case of this work by Degas. The boundaries between drawing and painting in this picture are impossible to define.

Edgar Degas, After the Bath *(detail) Pastel. Drawing or painting?*

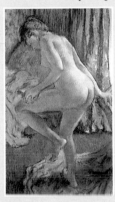

draw anything. This is because the nude theme summarizes the most important questions that affect drawing in general: proportions, shading, and composition.

Watteau, Study of a Nude. *Drawn with Conté and chalk on cream-colored paper.*

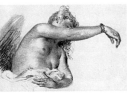

DRAWING IN ANCIENT TIMES

Humans first expressed themselves artistically through drawing. Evidence of this can be found in the drawings on the walls of caves where prehistoric people once dwelled. Drawing was humankind's first form of communication—long before the use of words—and it was also the foundation of all plastic and decorative art forms. It is essential, therefore, to study ancestral culture in order to know how those first primitive drawings gave rise to the birth of art.

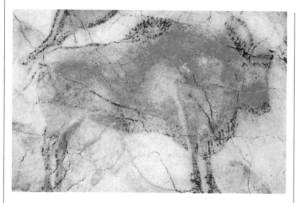

Bison of the Altamira Caves, Santillana del Mar, Spain. An example of the realism achieved by the first artists.

Drawing during Prehistory

Humankind's need for expression came about during the same time people started to invent hunting tools. Cave art was born as a magical medium to approximate the animal subjects in the normal hunting areas. From the beginning, the synthesis achieved in drawing had a great repercussion on the representation of shapes; these first drawings captured the forms of their subjects though a combination of clean, precise lines.

Egyptian Use of Line

Egyptian art was based entirely on line drawings with no shading or value changes. Ancient Egyptian art is found in tombs, meant for the life that was to continue beyond death. These pictures depict the dead person's past life and properties and were generally first drawn on limestone boards called *ostraca*. The final work was then carried out on pa-pyrus or on a wall.

Greek Perfection

The history of Greek drawing begins with the first Olympic Games.

In 776 B.C., chroniclers of the time, such as Pausanias, Plutarch, and Aristotle, spoke of the great Greek artists and draftsmen, among them Polygnotus and Zeuxis.

Drawing attributed to Onesimous (circa 480 B.C.). Woman Preparing a Bath. The perfection of Greek drawing and proportions have been the main points of reference of Western art through the 20th century.

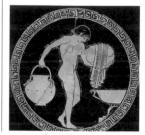

Drawing was the basis of all Egyptian art. Painting consisted of outlines that were then filled in with color. This style continued unaltered for thousands of years.

Greek artists represented the human figure in drawing with almost perfect precision. Their knowledge of drawing techniques and foreshortening allowed these artists to develop a figure that would remain a canon of beauty up to the present.

Perspective and Perfection in Roman Drawing

During the expansion of the Roman Empire, Roman culture literally absorbed Greek culture, and Roman art totally imitated that of the Greeks. Nonetheless, Roman draftsmen carried out complex studies on how to represent the third dimension on a two-dimensional surface, discovering what, centuries later, during the Renaissance, would prove to be one of the greatest breakthroughs in art history. The development of perspective was employed almost entirely on wall paintings, in a style correctly defined as architectonic, which would later on become known as Illusionist. This style recreated doors and windows as was done in the Baroque and was

House of Livia, in the Palatino. *An extremely realistic mural painting with the use of perspective. This picture corresponds to the second of the four artistic styles, architectonic, which is characterized by the way the elements are placed in perspective.*

Vetti House, Pompeii. *This mural was painted in the Illusionist style. The artist's use of perspective combines the three former decorative styles: incrustation, architectonic, and ornamental.*

the precursor of trompe l'oeil, which created the illusion of perspective with the purpose of deceiving the eye.

The Delicateness of Asian Art

The most prominent feat-

MORE INFORMATION
• Codices and miniatures **p. 10**
• Copying the masters **p. 12**

Asian Influence on Contemporary Art

Avant-garde artists of the 20th century were greatly influenced by Asian art. It had a strong influence on the Impressionists, both in the representation of space and in the predominance of the drawing in the development of the work. Ancient Asian art techniques are still prominent in many contemporary works.

Katsushika Hokusai, Birds in Flight. *This outstanding 18th century Japanese artist had an enormous influence on the Impressionists.*

ures of ancient Asian art are its delicate lines and special use of space, characteristics that had an enormous influence on 20th century avant-garde painters.

There are two classic styles of expression in Chinese art: linear and tonal. The linear shape is based on outlined forms that are painted with flat colors. The tonal style is based on shades of color rather than lines. This technique, which was particularly used for landscapes, emerged with the invention of paper in 105 A.D. Asian art was mainly based on the techniques of watercolor and wash paints applied over a drawing.

Kuo-Hsi, Chinese Winter Landscape. *Chinese art, based entirely on a drawing, was predominantly spatial.*

CODICES AND MINIATURES

The evolution of drawing as the base of the fine arts is seen in the decoration of illustrated codices and sacred books during a time when art was generally only found contained within the thick walls of monasteries. Miniaturists drew and illuminated the literary scenes that accompanied the texts with the aim of making them more pedagogical and understandable. Drawing served as a base and support on which ancient manuscripts were preserved.

Ademar de Chabannes, Repertory Codex. An Illustration of a Text by Higinio. This ink calligraphy on parchment is the work of the illustrator himself.

Calligraphy in Manuscripts

Calligraphy and drawing have always been intimately related. Codices were first illustrated around the 15th century, a fact that was fundamental to the development and maintenance of drawing as the foundation of illustration.

At first, toward the end of the first millennium, a codex was normally written and illustrated by the same hand. But gradually the work was divided into two fields: calligraphy and illustration. This specialization gave rise to the creation of books exclusively dedicated to examples of calligraphy and drawings, which monks used as models to copy.

Pedagogical Illustration

In the Middle Ages, drawing became the main means of propagating culture. This is why artists stylized their figures and abandoned the techniques of foreshortening and perspective. Codex illustrators, as well as sculptors of religious themes, took great pains to execute works of a purely pedagogical nature that were intended primarily for teaching or contemplation rather than for enjoyment.

Court Illustrations in Sketchbooks

Literature had a profound impact on the development of art. With the appearance in 13th century France of chansons de geste and books of chivalry in the royal courts, illustrators discovered new themes. Drawing was once again used to capture court scenes, and heroic battle scenes with great mastery in some cases. It was the dawn of Gothic art, and the style employed in these different drawings gradually distanced itself from the Romantic hieratic attitudes.

Einsiedeln's Studio, Liber Officialis. Nib and brown ink on parchment. Codex drawings of scared scenes and persons took on a decidedly educational and informative nature.

MORE INFORMATION
• Drawing in ancient times **p. 8** • Copying the masters **p. 12**

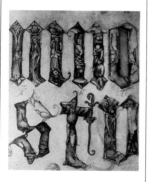

Giovanni de Grassi, Book of Models, Capital Letters. The letters were written using a silver point, a nib, and colored wash.

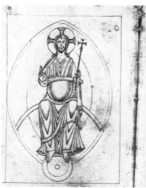

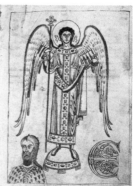

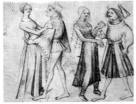

Bohemia Studio, Two Couples Dancing.

The Development of Drawing in Treatises

Although there are occasional references in medieval treatises to drawing as an independent art form, it was not until the end of the 14th century that drawing was recognized as such, when Cennino Cennini stated in his book *Il Libri dell'Arte:* "the intellect delights in drawing." At the same time, drawing in treatises became less didactic and more intellectual. In other words, illustrators made great efforts to provide detailed drawings on the subjects of anatomy, architecture, and medicine, thus developing new techniques such as foreshortening and chiaro-

Art and Science

Renaissance humanists created an interest in art and science, to such a degree that it was often difficult to separate one from the other. The quintessential representative of this intellectual and artistic movement was Leonardo da Vinci (1452–1519). His legacy constitutes a wealth of unequaled genius, sensibility, and scientific rigor.

Leonardo da Vinci, Study for the Adoration of the Magi. *Nib and brown ink.*

scuro in order to make the works more realistic.

The Study of Perspective

Artists like Paolo Uccello and Piero della Francesca developed theories of perspective in order to create exact representations of reality. Renaissance artists were fascinated by perspective, to such a degree that practically all the objects they drew were literally distributed on geometric planes before their definitive volume in space was developed. Drawing had acquired a more scientific character. The way in which perspective was used in order to obtain a better understanding of reality greatly influenced the development of other art forms.

Pierro della Francesca, De prospectiva pingendi *(circa 1482).*

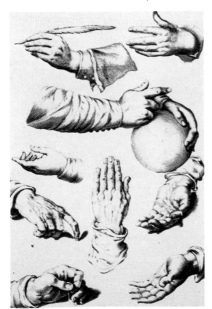

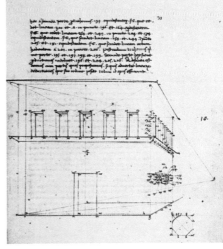

Plate for a treatise. Les principes du dessin. *Gérard Lairesse. The graphic information found on treatises were drawn with scientific precision.*

COPYING THE MASTERS

Most people learn how to paint by studying the paintings of the great masters. Drawing is the foundation of the understanding and development of the artistic work; therefore, it is advisable to study and copy the techniques of artists such as Michelangelo, da Vinci, and Caravaggio. This will allow you to understand the calculation of proportions, the creation of shadows, and the particular vision of reality that such artists had.

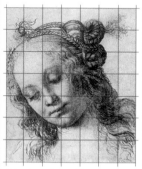

It is extremely useful to copy paintings by masters like Verrocchio.
Copying allows the artist to discover a whole host of drawing possibilities. You can use a grid to draw this Head of a Woman with a Complicated Hairstyle. In order to copy the image, you should draw a grid to place over the original picture and draw another one of exactly the same size on a blank sheet of paper. Then it is simply a question of transferring the lines from one grid to the other.

Masters of the Quattrocento

Masaccio, Donatello, and Brunelleschi were the pioneers of Renaissance art. These three artists created a thirst in 15th century Italy for knowledge in all senses of the word. Piero della Francesca and Paolo Uccello developed Brunelleschi's theories of perspective and a new era developed for the drawing arts, in architechtonics, portraiture, and anatomic study. By the Quattrocento, artists were drawing with practically the same techniques that we know and use today. Therefore, it is important for today's artists to familiarize themselves with the methods employed at that time.

Masters of the Cinquecento

The copying of old masters, like Michelangelo, da Vinci, and Raphael, is an excellent way to learn about the intricacies of drawing. A masterful use of light and shading, as well as the execution of lines, can be found in their works. All you need to

Leonardo da Vinci. Study of the Face of the Angel of the Virgin of the Rocks.

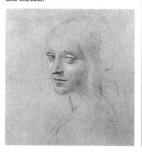

copy a drawing is a pencil and paper and the model. You may find it difficult at first, but as you gradually acquire the technique you will find it easier to understand forms and the type of strokes required to obtain them.

The Most Classical Drawing Tool

From ancient Rome to the Renaissance, the most common tool used to draw was the metalpoint or stylus, which, when sharpened, produced a line less intense than that made by a lead pencil.

The metalpoint was a delicate instrument made of soft metal and, although it has fallen into disuse, it is certainly worth testing it out for yourself.

Since you cannot buy a metalpoint in art supply stores, you can make one for yourself. A plumber can supply you with a pencil-shaped piece of lead or solder. Sharpen the tip

A schematic approximation of the structure of the drawing.

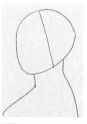

The placement of the main facial features.

The development of a copy of the drawing by da Vinci, drawn with sweeping strokes with a felt pen on paper.

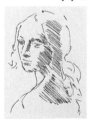

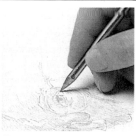

The metalpoint or stylus produces fine lines that are somewhat softer than those drawn with a hard lead pencil.

with a pencil sharpener and draw.

Volume with Highlights

When you start to copy a master like Raphael, it is essential to analyze both the direction of the stroke and the construction of the volumes. To do this it is best to work on colored paper, because it allows you to create contrasts between the color of the paper itself, the charcoal or Conté stick, and one or two applications of white chalk, which are used to bring out the highlights that create the effect of volume in bodies.

The white chalk highlights are normally added at the end

Raphael, Woman Reading to a Child. Drawn with a metalpoint, with white chalk highlights, on gray paper.

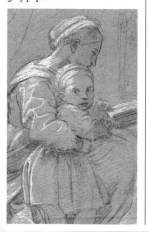

From Wash to Line

As the 20th century advances, we note that drawing in many of the new movements has gradually separated from other artistic forms. The line has undergone a profound transformation from the beginning of the century to the present day. With Cubism—a revolution in our concept of space—observe that the depiction of dark values translated into an understanding of planes that often led to clean, linear, often shadowless, drawing.

George Grosz, Men in a Café. The clean line defines the planes that are superimposed on it.

of the drawing, when you have already resolved the evaluation of grays, because the white areas represent the zones of maximum light, and result in a separation from the background.

Avant-garde Drawing

The avant-garde movement, which emerged at the end of the 19th century and continues to this day, made a complete break with the styles of earlier eras. Artists' drawings included themes unheard of until then and almost all aspects of technique changed.

Impressionism and post-Impressionism meant a new way of seeing shapes, exploring how the eyes perceive light; careful representation was replaced by impressionist tones, zones of mutual black and white contrasts that were used to bring out volume. Later on it was the turn of other isms, each of which contributed new techniques to the art of drawing.

Matisse, Woman in a Chair. Charcoal drawing. Later artistic trends tended toward greater synthesis in both form and stroke.

MORE INFORMATION:
• Drawing in ancient times **p. 8**
• Codices and miniatures **p. 10**
• Anatomy **p. 16**

Manet, Portrait of Madame Jules Guillemet. Charcoal drawing. The classical gradation of gray tones is replaced here by solid areas of black and white.

THE GEOMETRY OF OBJECTS

All objects can be represented on a two-dimensional plane. One way of understanding the lines that enclose the volume of different objects is to summarize them as a collection of basic two-dimensional geometric shapes. This way we can then reconstruct them to represent any object in nature.

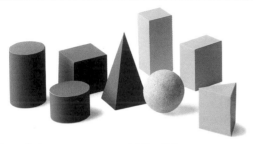

Geometric shapes are easy to draw. The four most important ones are the pyramid, the cube, the cylinder, and the sphere.

Simple Forms

The basic structure of all elements of nature can be reduced to four basic shapes: the cube, the sphere, the cylinder, and the pyramid.

An important exercise to do before embarking on representing a complex object is to draw some pure geometric shapes. Once you have mastered and understood them, you will find it much easier to draw more complex models.

The Cube

When you are going to draw an object, it is always advisable to try and understand it by seeing which of the four basic forms we mentioned earlier is closest to it in shape. This is done by studying the most significant lines of shape. For instance, a chair is similar to a cube.

On paper, the cube is represented in parallel perspective, using the front and bottom planes as the basis of the drawing. Since the four sides of each plane are identical, the upper and lower planes are equal. If you reduce this chair to a cube, you can see that the plane of the backrest occupies the same space as the rear plane of the cube.

The Sphere

The sphere is, in principle, the handiest of all geometric shapes because it can be used to block in all kinds of objects: from all viewpoints the object in question is surrounded by a circular structure. However, it is difficult to locate an object within a sphere because we have to take into account the direction of light.

The basic shape of a chair can be obtained by drawing a cube and extending the rear plane to double size.

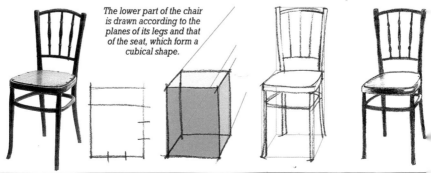

The lower part of the chair is drawn according to the planes of its legs and that of the seat, which form a cubical shape.

Spherical shapes can be represented by circles. The direction of the light on the model affects the size of the geometric plane.

The geometry of objects can be depicted by several geometric shapes inside of another basic geometric shape. For instance, this cylinder encloses two partial cones and a sphere.

The Cylinder

The cylinder differs from the sphere in that it has three planes that can perfectly surround the base and height of any object. The cylinder is composed of two planes at the top and bottom, and a curved plane that indicates the height of the figure. The upper and lower planes appear elliptical when observed in perspective. We can use various geometric shapes to represent the general shape of a figure; nonetheless, it is better to carry out a first appraisal using the most basic geometry.

The Pyramid and Sets of Shapes

Nature's most complex geometric shapes are the pyramid and the cone. The former has a polygonal base while the latter has a circular base. Initially, the pyramid is too complicated to use as a basis for the development of geographic shapes; however, it comes in handy in drawings that require further geometric development. For example, a vase enclosed within a cylinder can be reduced to a conical shape inside a cylindrical form.

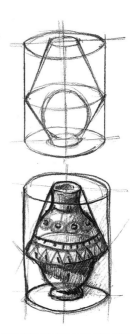

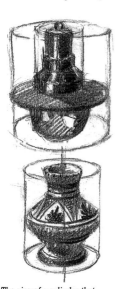

The size of a cylinder that surrounds an object is determined by the height of the object and its maximum diameter.

Geometry and the Human Body

The human body can also be reduced to the same basic geometric shapes in order to understand its three-dimensional form. The geometry of the different parts of the body indicate the foreshortening and position of the forms that make up a particular pose.

The different parts of the body represented solely as cylindrical shapes.

Using different geometrical figures allows us to understand the relationship between the different parts of the body.

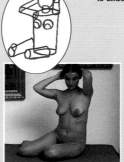

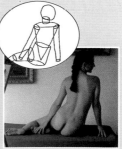

MORE INFORMATION

- Composition and sketching **p. 38**
- Blocking in, structure, and sketching **p. 40**

ANATOMY

The best way to learn how to draw the human figure is by studying its structure. Anatomy allows us to understand the proportions and shapes of the human body. Drawing is ideal for carrying out an exhaustive comparative analysis of all types of human forms and poses.

The spinal column is not rigid, and changes its curvature according to the positions of the lines of the shoulders and hips. The postures of the human body therefore dictate the positions of these three lines.

The position of the spine and of the lines that indicate the shoulders and hips define the position of the body.

Musculature and Bone Structure

Our muscles give shape to our bodies; therefore it is important to understand them as well as bone structure. Each muscle has a particular amount of flexibility, as well as a greater or lesser capacity for fat accumulation. One way of learning the position and shape of different muscles is to compare your personal drawings with figures shown in an anatomical atlas. For instance, draw the skeleton of a figure; then place a transparent sheet of paper on top and add the muscles, and finally use another transparent sheet and "dress" the figure with flesh.

The Need to Know Anatomy

The skeleton gives the human body its structure. Therefore it is important to understand the skeletal structure in order to draw human anatomy correctly.

To draw a skeleton correctly, the artist must make sure that all the bones are in proportion to one another.

Bone structure, like all other objects in nature, must be treated synthetically. So, instead of trying to capture the details of bone shapes (although there is no reason why you shouldn't attempt this), it is better to concentrate on the basic shape; this allows you to see the human skeleton as the structure of a living body rather than a collection of bones.

The Spine, the Central Axis of the Body

The human body is a complex collection of lines, volumes, and forms. The artist can acquire a sound knowledge of human anatomy by reducing its different parts to basic geometric shapes. The central axis of the human body is the spine. From this axis extend the two perpendicular lines of the shoulders and hips.

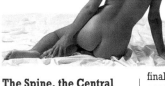

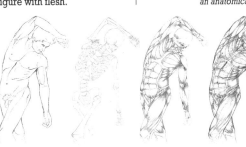

One way of drawing the human body is by tracing with the aid of an anatomical atlas.

Applying the Study of Anatomy

The study of anatomy has a practical application in draw-

A rough sketch of a human skeleton seen from the front and the side.

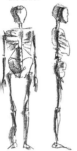

With enough knowledge of the human skeleton, the artist can draw even a rough sketch that will appear realistic in form and movement.

The study of the joints in a female body. It is important to know the position of each one of the muscles and bones in order to obtain a correct representation.

ing. It is one thing to understand the human body's bone and muscular structure in order to capture the figure in movement, but it is an entirely different matter to understand the intricacies of muscle movements, for which a comparative study of the position and shape of muscles and how they are represented in drawing is essential.

A study of the muscle structure of a woman lying down. The positions of the muscles have been drawn with the aid of an anatomical atlas.

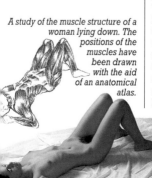

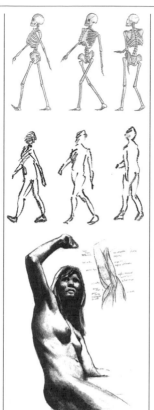

A Quick Sketch

Concrete problems frequently crop up when we are drawing a figure: How does this shoulder go? What's the position of the hips? The best way to deal with this type of problem is to draw a rough sketch of the figure's muscular and bone structures. It is not necessary to have a living model for this type of work, since a basic knowledge of the different parts of the human body is enough. With this exception, the artist should always work with a model, both for sketching from nature and for improving the artist's knowledge of human anatomy.

Da Vinci's Way of Studying

Leonardo da Vinci (1452–1519) drew countless anatomical studies in order to master the drawing of the human figure. He often used corpses as models, which he examined meticulously in order to discover the exact positions of the body's muscles. Comparative anatomy was one subject to which the master continually returned.

Leonardo da Vinci, Studies of Legs. The painter often compared human anatomy with that of animals.

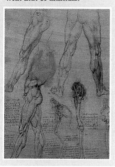

A study of human anatomy can solve problems of positioning and foreshortening. In many cases, the artist does not need a model, although it is always best to draw from nature.

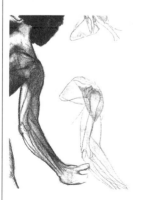

MORE INFORMATION
• Human proportions p. 18
• Modeling a figure in Conté p. 76
• The nude p. 90

HUMAN PROPORTIONS

There exists a series of rules or measurements for proportioning the human figure. These rules or canons have changed constantly throughout art history. The criteria used for the canons of different epochs were very much dictated by the esthetics of the day.

Proportions for Drawing the Figure

The drawing of a human figure is governed by two basic factors: a knowledge of human anatomy and correct mastery of the proportions between each one of the figure's or model's limbs.

The aim of the study of proportions is to establish a guideline to obtain the measurements of the human body's different parts. When several artists of an epoch use similar or identical proportions, they become a canon. In fact, there is a canon for every artistic period.

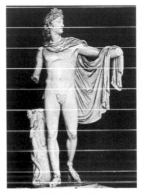

Apollo of Belvedere. *This sculpture is based on a canon of eight and a half heads.*

Classical Proportions

The study of human proportions is fundamental. Therefore, the study of the ideal proportions employed in different epochs can help the artist to understand that what he or she is really aiming at is to find the right balance between the measurements of the different parts of the human body and thus establish a rule.

The figures of ancient Greek drawing were very stylized and perfectionistic. The Greeks established a canon of a height of eight and a half heads for a man.

This system of measuring with heads has persisted to the present. This does not mean to say that an artist measures his or her model's head in order to know how tall the rest of his or her model is. It is merely an interesting anatomical study for finding out the height of the

average human being.

The Renaissance Canon

The objectivity with which Renaissance artists studied the human body led them to return to the classical view of the size and proportions of the human body. Throughout history, this canon has been used as a guideline to obtain a perfectly balanced body. The scientific procedures employed by the scholars of the Renaissance led each one to his own conclusions, which were expounded though numerous drawings.

It is useful to bear in mind the various ideal proportions so that you yourself can draw your model with accurate proportions.

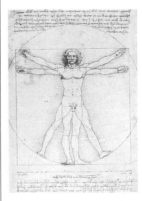

Leonardo da Vinci, Study of the Proportions of the Human Body. *Leonardo concluded that a man's outstretched arms had to be equal to his height in order to obtain his correct proportions.*

Micerino and his Wife. *In Imperial Egypt the average human figure measured eighteen fists in height.*

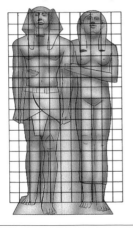

Complex Proportion in Foreshortening

When you are drawing a figure with a great deal of foreshortening, the body's different proportions must be established by looking at the model itself. How the proportions are depicted is entirely dependent on the position of the body, since the size of the different parts of the body will not correspond to the proportions of the body when it is in a simple pose. The sizes in the drawing must not depend on the normal proportions but on those that are obtained from the angle and perspective of the model.

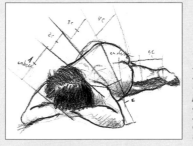

The different measurements do not depend on the normal proportions but on measurements taken directly from the model.

ences are located in the background, occasionally hidden by the body itself. In this case, the artist must construct the proportions with foreshortening, that is, if the model measures eight heads, this should be used as a reference in order to reduce the proportions according to the angle of the body's incline, provided that the foreshortening is not excessively pronounced.

Studying proportion leads to understanding shapes, including those that appear complex.

MORE INFORMATION

• The geometry of objects **p. 14**
• Anatomy **p. 16**
• The study of the human head **p. 22**

Practice Proportions

Every artist has his or her own method of sizing up the different proportions of the human body, so regardless of position, the various proportions of the model can be correctly drawn.

The most essential thing to remember is to establish a fixed standard of measure-

ments, which should be used both on the model and on its representation on paper. This fixed measurement can approximate a certain part of the model's anatomy, for instance, the head, which we can use as a unit for measuring the rest of the body.

This procedure can also be used to represent a complex pose in which the visual refer-

In this pose, the measurements depend on proportions with respect to the head and shoulders. The division of lines here correspond to a single standard, and the spaces separating them narrow as the plane recedes.

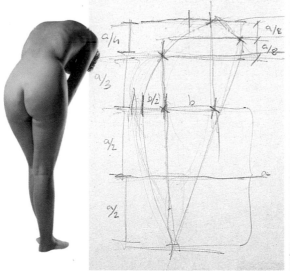

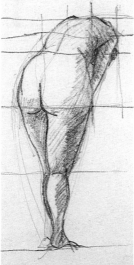

DRAWING FACIAL EXPRESSIONS

The use of line allows us to study and represent the face as well as to create portraits. Drawing is the medium that best allows the artist to combine the features of the face in the most realistic manner. Only with a good sketch that depicts the features as well as the general context of the face can we draw a natural and lively expression. Furthermore, it is important to understand the different facial muscles in order to achieve a particular expression.

A study of the different movements of the jawbone.

The Anatomy of the Face

The artist must become familiar with the muscles and bone structure of the face in order to draw facial expressions. He or she must learn the structure of the skull as well as the position and volume of the facial muscles.

The best way to tackle this problem is by drawing anatomical studies of the head, beginning with an examination of the skeleton in order to understand the volume of its

The principal facial muscles.

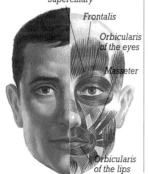

Superciliary

Frontalis

Orbicularis of the eyes

Masseter

Orbicularis of the lips

different shapes. The mandible or jawbone plays a fundamental role in facial expression, since it indicates the angle of the head, and is the area in which the facial muscles contract.

The masseter group of muscles, the frontalis, the spheres of the eyes, and those of the lips control facial expression. But there are also smaller muscles that enable us to wrinkle our nose or smile; they are known as the supercilius (eyebrow muscles), the levator of the upper lip, the major and minor zygomatic muscles, the buccinator and the risorius (which control mouth movement), the triangularis muscles, and the levator menti.

Smiles and Laughter

A smile is formed when the muscles pull the lips slightly apart by raising the corners of the mouth and moving them sideways. This causes the skin at the sides of the mouth to puff slightly and the eyes to half close. If the smile is spontaneous, the forehead and eyebrows appear relaxed.

Laughter brings many more

The smile partially distorts the face; the mouth opens and stretches and the eyebrows change shape.

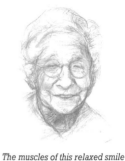

The muscles of this relaxed smile widen the mouth and pull the corners sideways and upwards with only a slight arching of the eyebrows.

of the facial muscles into play; the mouth is open much wider and the upper teeth are sometimes visible. The facial muscle structure changes due to the effect of contracting; the eyebrows arch, creating wrinkles across the forehead and the rest of the face.

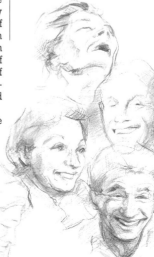

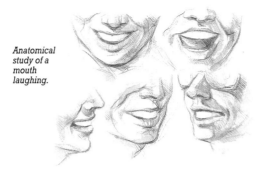

Anatomical study of a mouth laughing.

The expressions on these faces have been constructed from a sketch of lines that make up expression.

Pain and Grief

The face's different expressions are the combination of the movement of each one of the facial muscles. Expressions of pain, sadness, and grief are principally expressed by the eyes and the brows. Generally, pain is expressed by facial contraction and frowning, an action that lowers the

eyelids. It is advisable to practice these expressions in sketches. One practical way is to place a mirror in front of you and adopt different expressions in order to study them closely.

Expressions of sadness and pain are characterized by the knitting of the eyebrows and the lowering of both eyelids.

Anger, Fear, Hate...

Intense feelings such as hate and fear, are expressed by a host of wrinkles that define the face by combining the expressions of the eyes, brows, and mouth. A drawing can construct expressions from a series of simple lines that eventually establish the basis of the more intricate lines that create volume and form. You should always begin with a general sketch of the face before including the final form of the expression.

MORE INFORMATION
• The study of the human head **p. 22**

Learning from the Masters

To understand how the facial features are related to each other, it is essential to know the anatomy of the head and the limits of the different muscles. One way of furthering your knowledge of the subject is to copy the great masters; Leonardo da Vinci's drawings are authentic studies of anatomy with an impressive expressive strength.

Copy in Conté of a drawing by Leonardo da Vinci.

THE STUDY OF THE HUMAN HEAD

The head is one of the most difficult parts of the human body to draw. Nonetheless, by studying the volume and proportions of each one of its elements, as well as their position on the face, these difficulties can be overcome. As a warm-up for a portrait, it is best to carry out an in-depth study of the head with the aim of situating the features in their respective places.

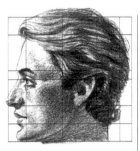

The construction of a canon facilitates the correct alignment of the different parts of the head.

The Construction of a Canon

The human head, whether drawn as part of a figure or a portrait, must have a guide by which to place the facial elements. We construct a canon, or rule of thumb, through a simple geometric calculation: We construct a rectangle the size of the head and divide its width and depth into three and a half parts. Each one of the segments obtained establishes the proportion of the zones of the skull, as you can see in the illustration above.

The Planes of the Head

Note how each of the facial features is set within one of the canon's modules. These measurements belong to a preestablished canon, but each artist is free to create his or

The canon of a child's head differs from that of an adult.

her own, provided there is a balanced relationship between the measurements.

This canon can be applied to any head; however, it is best to adapt it according to the facial structure of the head.

Analysis of the Face

Every face has its own particular characteristics. The

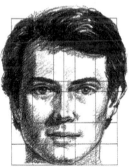

size, shape, and relationship among different features is unique to each individual. The application of the canon to the face allows us to define each one of the face's zones and establish an initial structure of the face. In order to success-

fully draw a face, you should first draw the main lines indicating the main points, for instance, one line establishes the height of the eyebrows,

MORE INFORMATION

• Anatomy **p. 16**
• Human proportions **p. 18**
• Drawing facial expressions **p. 20**

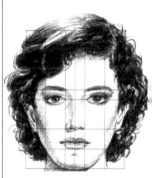

The different planes of the head are situated within the canon grid.

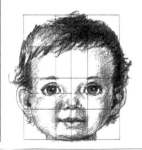

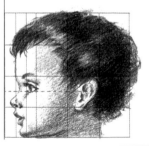

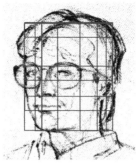

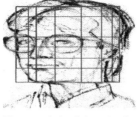

The anatomical variations of each individual can be added, once the head has been drawn according to the canon.

Variation on the Canon: El Greco

The deformed figures painted by El Greco were initially mistakenly attributed to the artist's sight, a theory that was later disproved. It was a question of personal esthetics that led the painter to represent his subjects as he did. It is El Greco's own particular canon that lends such elegance to his work.

two vertical lines delimit the width of the nose, and so forth.

The Structure of the Head According to the Pose

When representing a face, its structure should never be viewed as a static combination of lines, but as a guide to an accurate drawing. Therefore, the structure must be adapted to the position and angle of the face. Try to imagine a cubic grid made up of wires within which a head is located. In this way it is easier to understand that the lines delimiting the structure of the face will vary depending on the angle of the face.

The position of the head does not imply any variation with respect to the canon. It is merely a question of adapting the canon so that the grid maintains the proportions according to the angle.

Proportion and Features

The proportions of the face vary with each person, so the size of the features is determined by comparing them to the rest of the face. A nose is

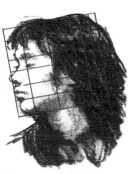

The canon can be varied according to the aims of the artist.

only large if the proportion between it and the other features make it so. When drawing a face, therefore, it is essential to balance the sizes of the different features of the face in order to obtain a proportioned drawing.

El Greco, The Resurrection of Christ.

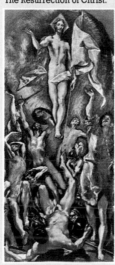

PAPER: MANUFACTURE AND TYPES

You can use virtually any type of surface to draw on, although most artists prefer to draw on paper. There are many types of paper from which to choose. In fact, there is a type of paper for every occasion and for every drawing medium. The quality of a type of paper depends entirely on its origin, manufacturing process, priming, and gloss. These factors affect the weight of the paper, and whether it be for use with charcoal, pencil, or another drawing medium.

Types of Paper

Basically, drawing paper is divided into two types: industrially manufactured paper and handmade paper, although within these two categories there exist a number of qualities that are classified by the purity of the materials used to manufacture it. Other considerations to bear in mind are whether it is primed, pressed, and so forth. The thickness of drawing paper is determined by its weight; the heavier the paper, the thicker it is.

The type of paper you choose depends on its planned use. The choice ranges from glossy paper to the rough texture type. A drawing executed in ink requires a glossier paper; drawings in pencil and other dry media, such as graphite, pastel, Conté, or charcoal, should be executed on textured paper.

(1) Smooth texture (Arches), (2) Medium texture, (3) Rough texture (Canson), (4) Daler, (5) Canson Bristol, (6) Whatman, (7) Fabriano, (8) Guarro, (9) Offset, (10) Grumbacher, (11) Schoeller Hammer.

Manufacturing Paper

It is relatively easy to make paper if you have the right equipment. Furthermore, handmade paper lends the drawing certain rich qualities.

Paper can be made from waste paper, in which case it is shredded and left to soak until it acquires a soft consistency. Then the paste is made into pulp by beating it or stirring it with a type of electric blender. The paper is left in suspension until it has completely dissolved. A quantity of powdered glue or latex is then

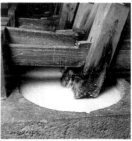

Paper pulp obtained from water, glue, waste paper, and cotton rag.

added to it. Then a fine wire mesh screen is lowered into the container to collect enough paste to make a single sheet; the deeper the screen is lowered, the more pulp it picks up.

Once the water has been drained, the paper is placed between felt and a fine cloth for later pressing in order to remove the remaining water.

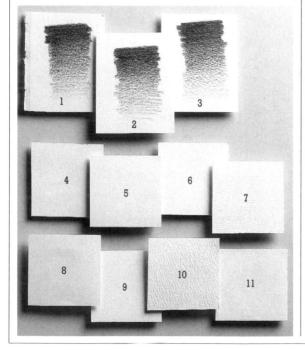

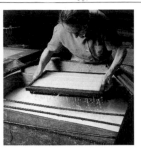

Filling the screen with pulp. One page is extracted at a time.

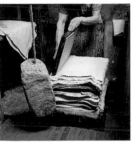

The drained sheets are placed between felt and fine cloth.

The paper is pressed to give it consistency and to remove the remaining water.

Storage

Paper is extremely sensitive to humidity and climactic changes. It must always be protected from the atmosphere. You should make sure that the paper has dried completely before it is stored, otherwise damp stains can form on its surface. It must be stacked horizontally, ideally in special drawers, but since these drawers are expensive and take up a lot of room, you can keep the paper in folders larger than the size of the paper.

One important point to bear in mind is never to store paper rolled up, since this will warp it and cause the fibers to expand.

Different types of folders for flat storage of used or new paper.

Colored Paper

Colored paper is ideal for drawing with charcoal, as well as serving as an excellent background color for drawings that require some white highlights.

Don't confuse colored paper with illustration board, which has no texture. Colored paper normally comes in medium or rough texture varieties. Drawing on colored paper provides the artist with a wide range of rich possibilities because he or she can integrate the color into the drawing.

Canson Mi Teintes colored paper samples.

MORE INFORMATION
• Lead pencil techniques p. 50
• Line and wash with dry or greasy media p. 60

The Expressive Potential of Colored Paper

A drawing can take on highly interesting expressive connotations when drawn on colored paper with two different drawing media, such as charcoal or Conté alternated with white chalk. The artist integrates the color of the paper into the drawing, using it to create an effect of a third dimension with white highlights, or simply as a contrasting color.

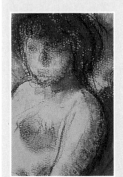

Detail of a drawing executed with Conté and charcoal on ochre-colored paper.
Artist: Francesc Serra.

PENCILS: HARDNESS AND QUALITIES

We all know what a pencil is, but this term covers an entire family of instruments, rather like the term fish includes numerous species of marine life with shared characteristics that lead them to be categorized under a general heading. There are soft and hard pencils, grease pencils, graphite pencils, charcoal pencils, colored pencils, pastel pencils, water-soluble pencils...and the list continues. It is necessary to be familiar with the different types and qualities of pencils in order to fully exploit this important drawing tool.

Lead or Graphite Pencils

A pencil is a stick containing graphite, formally lead. Though we still refer to lead pencils, remember that lead is no longer used. Each pencil is defined by the line and tone it produces. Graphite pencils are either hard or soft, a fact that permits a wide range of different tonal effects when drawing.

Most pencils have graphite encased in wood so that they can be held properly. There are also types of pencils that are encased in plastic. Pencils can be cylindrical or polyhedral. The use of an automatic pencil avoids having to sharpen the lead.

Qualities and Brands of Pencils

It is important to differentiate between pencils in terms of the quality, brand, and hardness of lead. We can use almost any medium to draw with, but a pencil is the most versatile of all drawing tools. Pencils may be divided into two categories: school quality pencils, classified by numbers, and high-quality drawing pencils, classified by numbers and letters. There are several ways of identifying a good pencil: the wood should not splinter when the pencil is sharpened; the lead, whether hard or soft, should not break too easily. Only high-quality pencils meet these requirements.

Hardness and Intensity

The hardness of a pencil is determined by the grade of the lead. The softer a pencil is, the darker and more intense its stroke. The numbers run in order of hardness. Number 1 is the softest. As the numbers increase, the intensity and possibility for contrast decrease.

Drawing pencils may have numbers and a letter, the latter indicating their hardness. For example, a pencil marked B with a high number is soft; thus it may be a good choice for shading a drawing or part of a drawing.

MORE INFORMATION
• Lead pencils techniques **p. 50**

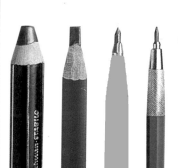

Graphite comes in a variety of shapes, each of which provides a different result.

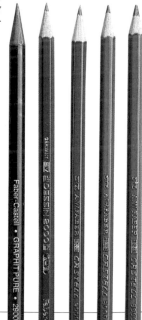

A 2B is a soft pencil and the softest of all is a 9B. An H pencil is harder than a B pencil and produces less contrast. A 9H is harder than an H or a 2H (see illustration).

The Grease Pencil

Some types of pencils have a greasy lead and produce a

The thicker the lead, the softer the pencil is.

wide range of tones, from the subtlest shade of gray to the most opaque planes. There also exist water-soluble pencils, which dissolve in water and are ideal for use with watercolors.

A grease pencil can be applied on all types of surfaces. It is useful for sketching the basic outline for a painting in an opaque medium like acrylic or oil. A non-water soluble grease pencil may be useful for the drawing before painting a watercolor. Its greasy lead serves as a water repellent and is used to prevent different colors from blending together.

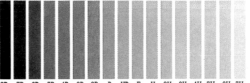

A scale of lead pencils from the softest (on the left) to the hardest (on the right).

8B 7B 6B 5B 4B 3B 2B B HB F H 2H 3H 4H 5H 6H 7H 8H 9H

HIGH-QUALITY PENCIL BRANDS

Origin	Company	Brand
Czech Republic	L & C. Hardmuth	Koh-i-nor
Germany	A.W.	Faber Castell
Germany	J.S.	Staedler Mars
Germany	Swan	Stabilo
Germany	Eberhard Faber	Van Dike
Switzerland	Caran d'Ache	Caran d'Ache
France	Conté	Alaska

Erasers and Automatic Pencils

An eraser is one of the most useful drawing tools. It can be used to correct an error or lift out white areas or highlights in a drawing.

Soft rubber eraser.

Common eraser

Soft plastic eraser.

Kneaded eraser.

Every drawing medium requires its own special eraser. So if you draw with waxy graphite leads, it is best to use a rubber eraser. When you want to erase a dry medium, such as charcoal, a kneaded eraser should be used. The use of an eraser should be kept to a minimum, since it tends to damage the surface of the paper.

Another extremely useful implement is an automatic pencil, which allows you to adjust the length of the lead.

A Useful Tool

An eraser is not only used for correcting errors, it can also be used for "opening up" white areas and highlighting outlines.

The eraser enables the artist to bring out light areas and highlights. Here an eraser has been used to lift out the highlights.

COLORED PENCILS

We can also add color to our drawings by using one of the various colored drawing media. Colored pencils come in a great variety of colors, and they are quick and easy to use for obtaining different shades of a color. If this were not so, drawing would be limited to shading tonal values.

Drawing and Color

A drawing does not always have to be executed in black and white, in fact drawing is not restricted to any one medium in particular. It uses dry media that, due to their composition and artistic results, do not tend to produce a great deal of color.

Nonetheless, it is important to bear in mind that we use colored pencils in exactly the same way we do lead pencils, in other words, instead of varying value by a range of gray tones, we do it with color. We use much of the same techniques: cross-hatching, taking advantage of the paper's texture, and drawing linear or shaded pencilwork.

The technique employed with colored pencils is practically identical to that of lead pencils.

Despite the wide range of colors available, colored pencils are considered a drawing medium.

The pencil should not be held at too wide an angle from the paper; this position increases the risk of breaking the lead.

Cross-hatching and Color

Cross-hatching creates a visual effect produced by the superimposing of crossed

Superimposing one primary color over another produces a secondary color.

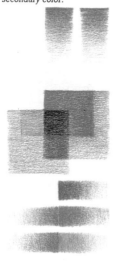

lines. With this technique we can create planes of a particular color and, by cross-hatching two planes of different colors, obtain a third color. By superimposing the three primary colors, we can obtain the secondary colors.

Although these two drawings look identical, the second has been drawn with the three primary colors and black, while the other was drawn using a wide range of colors.

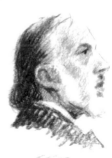

On the other hand, since we use colored pencils in the same way we do lead pencils, the resulting work is very close to a classical drawing. Thus, if we fully understand how to mix the three primary colors together, we can use four colors to create the entire chromatic palette.

Value Change with Color

The work of creating changes of value with colored pencils is always carried out from light to dark. In other words, the colors are progressively intensified, beginning with a minimum of contrast in the shadows, which is created by looking for the darkest points within each tone. The darkest values are produced with the buildup of color, which is always applied in the direction of the plane.

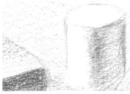

Colored pencil techniques begin with a soft suggestion of values, which establishes the darkest zones from the outset.

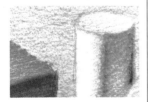

The tones are gradually intensified as they are built up.

The Potential of Colored Pencils

Colored pencils have a wide range of applications. They can be used to create glaze effects by superimposing color over darker layers. In this drawing executed with felt pens by Claude de Seynes, the mist effect was achieved with a soft layer of colored pencil, thus shrouding the underlying dark color.

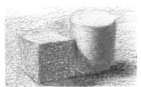

White can be used to create the soft look of a pastel drawing.

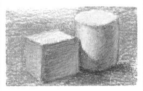

Highlighting

Colored pencils produce transparent color, and because of their plastic origin, are water soluble. Their lack of opacity allows us to create textures by making use of the underlying colors or the texture or color of the paper.

With colored paper we can add light areas and highlights, although, when we paint white over a layer of color, instead of appearing opaque, it produces the soft appearance of a pastel painting.

Using Colored Pencils

It is essential to study the direction of the strokes, since planes are determined or suggested by the direction of the lines that form them. For instance, the sea should be drawn with horizontal lines; a cloudy sky requires enveloping pencilwork, and a field would be drawn with short vertical strokes.

In order to create the different planes of your drawing, it is essential to draw the lines in the direction of the object on which you are working.

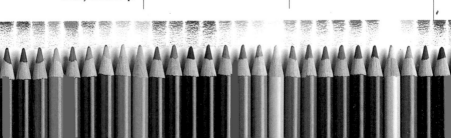

STUMPS

In drawing there is a tool designed for softenings shading and values: the stump. This drawing tool enables the artist to carry out subtle gradations and blending without the need to use a pencil. Like any drawing implement, the artist must practice using it in order to obtain satisfactory results.

Types of Stumps

The stump is a useful tool, but, like any other implement, it is useless if we do not know how to use it properly.

A stump is used for blending lines or areas drawn in pencil. Stumps come in a variety of shapes and sizes.

The commercially sold stumps are made of compact, rolled, spongy paper and have a point at either end.

A stump is used just for blending values and is a useful secondary drawing tool.

Technical Applications

The stump can be used for erasing small areas of a drawing, grading tones or creating uniform planes by merging pencils lines together.

There are many types of stumps, both in terms of size and in thickness. We recommend that you use a different stump for each color, in order to keep the colors clean.

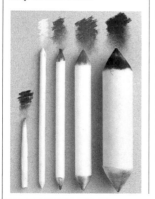

*1. Z-shaped blending
2. Blending a line
3. Adding a line over a blended area by extending the gray toward one side.*

We can also blend lines into large areas of color, and even blend the color of the line to darken underlying lighter areas.

Blending a dark area.

Improvising

Stumps offer the artist many artistic possibilities. For instance, take a sheet of paper and cut out a hole in the shape of a leaf; place it on a sheet of paper and shade along one side; then, without moving the paper, use a stump to grade the area toward the opposite side; then remove the stencil and draw the leaf's central vein

with a lead pencil; now place the mask back on the paper and softly blend the shadow; finally, lift out several white lines with a rubber eraser.

Blending Values with Your Fingers

Many artists do not use stumps but prefer instead to use their fingertips. In fact, each part of the hand can produce a different type of blended effect with a different

Having placed the stencil on the paper, some blending has been done to model the shape of the leaf and its shadows. Last, several white lines were drawn with the edge of a rubber eraser.

amount of pressure. The thumb is excellent for blending with a uniform amount of pressure, but, owing to its size, is not recommended for dealing with small areas or intricate shapes; the little or ring finger is best for this task. Light blending can be done with the other fingers, and the lower part of the palm is ideal for working open areas of color.

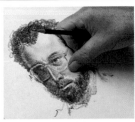

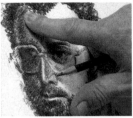

Blending and Shading in the Cinquecento

During the Italian Renaissance, artists concentrated all their efforts on achieving lifelike representations of their subject matter. The modeling of forms by means of light and shadow entailed grading zones from light to dark. In this study of an elderly man's head, Federico Barocci blended the area in shadow and contrasted it with some warm reddish touches of Conté.

Making Your Own Stumps

At one point or another you will almost certainly need to use a stump. You can make your own stump. Choose a piece of thick spongy-type paper, such as kitchen paper towels, or, if you want a sturdier stump, use newspaper or cardboard. Cut out a triangle of the size indicated in the illustration and roll it as if it were a hand-rolled cigarette. Finally, secure the paper with a strip of adhesive tape.

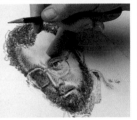

Federico Barocci, **Study of an Elderly Man's Head.**

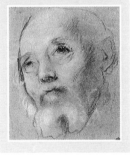

A simple procedure to make your own stump. Cut out a triangle, roll it up and secure the end with a piece of adhesive tape.

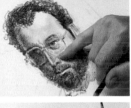

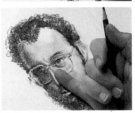

MORE INFORMATION
• Shading **p. 64**
• Chiaroscuro **p. 66**

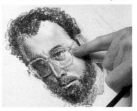

Blending with the fingers.

DRAWING WITH FELT PENS

The felt pen is one of the most recent drawing inventions. Since it first appeared in Japan in the 1960s, more and more artists have adopted this medium as a method of artistic expression. Drawing with felt pens is a delicate and complex labor; nonetheless, they have enormous creative potential that easily competes with all the traditional drawing media.

The Medium

The felt pen is a container with felt inside to carry the ink to the tip. There is a wide range of tips to choose from and every year new designs come on the market.

The type of tip determines the line it produces. There are thick tips, ranging from 0.5 mm in diameter to marker-type pens with tips measuring several centimeters across. Likewise, the tip can vary depending on the application for which it is meant to be used. There are tips made of felt that can be hard or soft, brush-shaped tips made of synthetic hair, rubber tips, and so on.

Stroke Variety

One of the characteristics that make this medium so versatile is the possibility of drawing different strokes using one single tip. Not all felt pens can do this, only ones that have a bevel edge or a

Different types of felt pens, tips, and strokes.

1. Fine line drawn with the edge of the point. 2. Medium line drawn with the narrower frontal side. 3. Thick line drawn with the widest part of the tip.

brush tip. The brush tip, as its name suggests, produces a line similar to a brush stroke, although the tone is always uniform; the bevel-edge marker allows three types of line: a fine line, when applied with the edge of the tip; a medium line, using the narrower frontal side; or a thick line, when drawing with the widest part of the tip.

Superimposing Planes and Values

The transparency of ink used with felt pens means it can be mixed or blended on the paper. As is the case with watercolor, the ink does not create opaque effects, for which reason there is no white

Felt pen ink dries immediately and thus allows blending and superimposing tones and color.

felt pen. In felt pen drawing, white is achieved by leaving the paper clean and unpainted. This transparent quality, together with the ink's fast-drying properties, permits the artist to superimpose planes, creating different tonal values or even new colors, if complementary colors are used to superimpose planes.

Techniques of Application

Gradations of value with felt pens can be created in two different ways. One method is with a colorless felt pen whose reservoir contains only xylene, a solvent.

This pen is used to dissolve the ink; you can apply the solvent over a color to grade down the color. The other method consists of thinning the color by blending it directly

WATER-BASE
WASSERBASIS
A BASE D'EA

neutral si
odeur neu

Felt Pen and Expression

There are many artists who specialize in working with felt pens. Some of them achieve surprising results with such an apparently simple medium...but in reality it requires a sound knowledge of drawing and light, as we can see in this drawing by Claude de Seynes.

Claude de Seynes, Portrait of Alice.

with a pale tone; in this way it is possible to create variations of value and color to create volume.

With felt pens, colors must always be painted from light to dark. In other words, we first apply the lightest colors and gradually add the darker ones on top.

Drawing and Color

The felt pen can be used to draw with color while maintaining its linear aspect, even

Gradation carried out by blending color with a felt pen containing transparent ink.

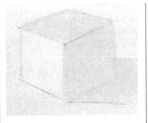

MORE INFORMATION
- Felt pens **p. 56**
- Ink: technical applications (II) **p. 74**

The continuous superimposing of tones increases the tone of the base color. The more you apply, the darker it becomes.

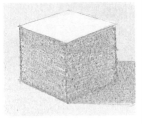

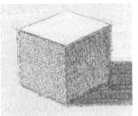

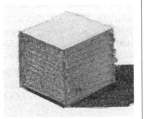

The transparent nature of felt pen ink requires the artist to paint from less to more.

though the end result does tend to appear pictorial.

The simultaneous application of different techniques should always make use of light, creating contrast by superimposing darker tones, although the darkest tones should only be used sparingly. The felt pen technique is based entirely on the interweaving of lines to create planes.

Miguel Ferrón, Boats in the Port. *This drawing, in spite of its pictorial effect, was executed with a drawing technique.*

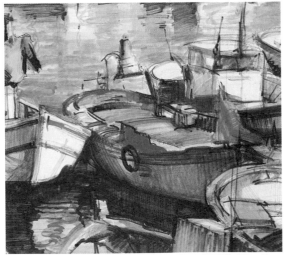

PASTELS

Pastels are halfway between drawing and painting since pastel pigment allows all types of strokes and lines, combining the general quality of drawing with the creation of totally opaque planes. The pastel medium can be considered both a painting and a drawing medium depending on what it is to be used for. We can use pastels to draw monochrome or colored pictures.

The preliminary work in pastels consists of a purely technical drawing.

Drawing and Painting with Pastels

Pastels can be applied in two very different ways. Pastels can be considered a completely pictorial medium, closely rivaling oil in terms of its plastic possibilities (blended color, values, pictorial effects, etc). Nonetheless, depending on how pastels are applied to the paper, this bright and opaque medium can be used as a drawing medium. Like all other drawing media, the first thing we must do when working with pastel is draw the basic lines of the model.

Stroke and Texture

Pastel lines are dry, so they can be applied over almost any type of surface. The application of this dry medium, like all other drawing media, depends on the texture of the paper. A very grainy sheet of paper allows the pastel to cover only the grain in relief, while the pores can only be filled in by applying more pastel stick or by rubbing the pastel into the

Rough texture paper looks like this after it has been colored with the flat side of a pastel stick. Blending pastel allows us to fill in the pores of the paper.

paper using a stump or your fingers.

Therefore, it is the texture of the paper that determines the texture of the drawing. This allows us to fill in the paper and develop contrasts of value in some areas while leaving the porous texture in others virtually untouched.

Opaque Strokes

The opaque nature of pastel permits different strokes to be superimposed without the

Developing shading with pastels enables us to simulate any drawing medium, but the incorporation and blending of other colors leads the work toward the pictorial field.

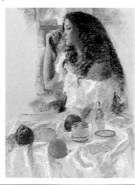

...establish the limit between drawing and painting, since a drawing does not cease to be a drawing simply because it contains color; likewise, a painting is still a painting even if it is executed with a linear treatment.

The most significant drawing qualities of pastel are its opacity and its covering capacity in values. Nonetheless, pastel is not a medium for mixing; there is a color for each occasion within its wide chromatic range. The opacity of pastel allows it to be applied over colored paper and enables us to superimpose lines over areas of different values of pastel.

Color Contribution

The application of a drawing medium does not exclude the use of color; in fact, this is one

The use of multiple strokes allows planes to be superimposed within a drawing.

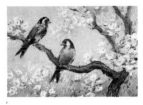

of the many qualities of this medium. A drawing can be executed in a completely linear fashion or, on the contrary, can be given contrast of light and shadow by means of lines or blending, which also lend the drawing volume. Through color, pastel permits a blending of strokes in a tonal gradation, a task that can be

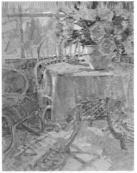

In this example the artist has used pastels to draw rather than paint, without areas of heavy color, which would make his drawing look more like a painting.

done with Conté crayon or charcoal, without having to revert to washes that can turn the drawing into a painting.

Different Subject Matter

The diversity of themes that can be painted with pastel covers all genres, from the portrait to the figure, from the landscape to the still life.

No matter what the subject is, it is indispensable to always allow the linear character of the drawing to prevail, otherwise your work will look like a painting. Pastel can be used to draw fast sketches and even color studies that can later be used as a complement for a completely pictorial work. But, whatever your aim, the initial structure of any picture begins with a drawing, which should

Stroke Density in Pastel Drawing

A clean stroke can be accompanied with color according to the artist's preferences without the picture losing the quality of a drawing. In this work by Toulouse-Lautrec, both the line and the color are clean and definite. Thanks to his powers of synthesis, the artist was able to achieve this outstandingly fresh and spontaneous drawing.

Henri Toulouse-Lautrec, In the Rue des Moulins.

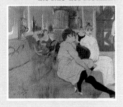

summarize the theme you are going to execute.

All subject matter is appropriate for drawing in pastel, but it is important to observe the limits of drawing when using pastels.

MORE INFORMATION

• Stumps **p. 30**
• Oil crayons and oil pastels **p. 36**
• Modeling a figure in Conté **p. 76**

OIL CRAYONS AND OIL PASTELS

These so-called pictorial media are very useful for drawing. Both oil crayons and oil pastels can be used for painting, since they are opaque media that allow the picture to be executed with washes or the superimposition of planes. Nonetheless, their availability in stick form makes them ideal for drawing.

Drawing with Oil Crayons and Oil Pastels

Even though oil crayons and oil pastels are pictorial media, they can be used for drawing. The difference between a drawing and a painting is often difficult to define, to such a degree that some drawings may be classified as paintings and vice versa. We generally define a drawing as a monochromatic linear work, even when the lines are drawn with several colors. Therefore, we can define drawing as a work that contains lines and, possibly, washes, provided they do not create color planes.

Due to their direct use and opacity, oil crayons and oil pastels are apt for drawing with, in the same way we use charcoal and Conté crayon.

A box of crayons.

Even pastel colors applied as washes can preserve the linear character of the drawing.

Preparing a Drawing for a Painting

We set out to draw a work with crayons in much the same way we would deal with a charcoal drawing. The only difference is that oil crayons and oil pastels are opaque and thus allow planes to be superimposed. This means that instead of having to sketch a perfectly finished drawing, we

Any drawing must start with an initial sketch.

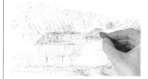

Similar to the way we work with charcoal and Conté crayon, the planes that are defined by directional strokes indicate their position.

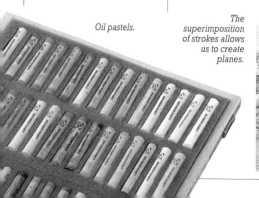

Oil pastels.

The superimposition of strokes allows us to create planes.

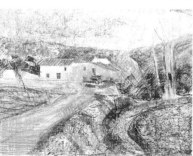

only have to indicate the most important lines, because when adding color we can change any initial stroke.

When we are aiming at a linear result, we should not fill in the planes too densely, but apply colored strokes to synthesize them and their textures.

Blending Strokes

Both pastels and oil crayons can be applied in much the same way as charcoal and graphite pencil, nonetheless oil crayons possess certain characteristics that unite the drawing and painting: they can be dissolved in turpentine in order to blend two or more colors together. Pastels, on the other hand, cannot be dissolved, but the colors can be blended by superimposing one color over another.

Drawing in oil crayons can be blended with turpentine by rubbing a brush loaded with solvent over the color. This technique turns what were formerly lines and strokes into a mass of color.

Combining Washes and Line

The oil crayon and oil pastel picture can still be considered a drawing no matter how sophisticated the picture. A wash can be combined with a line drawing without the work taking on the look of a painting.

Crayons allow us to obtain a linear picture.

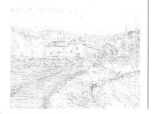

We can blend colors together with turpentine. The result is similar to a watercolor.

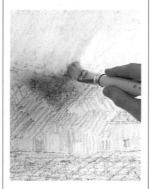

Pastels and crayons can be used to blend lines by applying pressure on the stick. In the case of pastel, it is best not to mix the color, since pastels become neutral and muddy when they come into contact with other colors. There is no real need to do this, since pastels come in a wide range

of colors that covers all our chromatic needs; crayons, on the other hand, can be mixed to obtain numerous artistic possibilities.

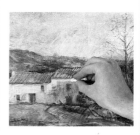

Oil crayons can be used to draw directly and then blended with turpentine to form planes.

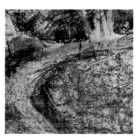

> **MORE INFORMATION**
> • Pastels **p. 34**
> • Felt pens **p. 56**

Alternating Washes and Lines with Turpentine

The use of pictorial media, such as pastels or crayons, in order to express oneself through drawing, increases the artist's possibilities by allowing certain pictorial characteristics.
Crayons can be blended to form washes by superimposing layers. The final work may look like a drawing or a painting depending on how the areas of solid color were obtained.

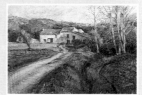

Both crayons and pastels can produce a drawing with a painting-like finish.

COMPOSITION AND SKETCHING

The initial placement of a drawing is seldom considered definitive, as the lines require adjusting before the picture is fully developed. This transition from a piece of blank paper to the first approach to the drawing is called *blocking in,* that is, summarizing shapes using a minimum of lines. Objects that are drawn pass through this initial phase before the final drawing is completed and the simple composition is enriched and developed as the resemblance of the object begins to appear on the paper.

Basic Shapes

The objects to be represented need to be placed on the paper before the definitive version is started. If we begin with the premise that all the forms of nature can be reduced to a few lines, this will

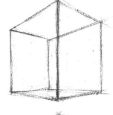

be of great help when situating the model on the paper. The shapes of these objects are reduced to several basic geometric shapes. This simplifies the task of positioning them and specifying their definitive placement within the drawing.

The basic forms represent the model using simple geometrical shapes.

Blocking In Forms

There exist several ways of approaching a drawing. One of the most common is to block in the geometric forms as polyhedrals, that is, several-sided objects. This basic form can be obtained with just a few lines, depending on which aspect of the drawing you wish to highlight, for example, the depth or the volume. This kind of sketching, which is always based on geometric forms, is used to block in urban landscapes, for instance, while it is

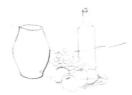

From these basic forms, the internal structures of the objects are developed.

Blocking in the subject using polyhedral geometrical forms.

Use of lines with polygonal figures for blocking in the forms.

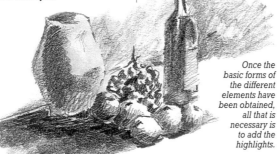

Once the basic forms of the different elements have been obtained, all that is necessary is to add the highlights.

seldom used for a still life.

Another system of blocking in attempts to use a schematic vision of the model, that is to position a square or a rectangle from which, little by little, the figure is created. Other artists prefer to directly

draw the lines of the figure's profile in a definitive manner.

Secondary Lines and Masses

When drawing a sketch, there are always certain areas that are secondary to the main struc-

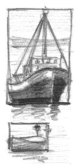

Drawing the figure directly. This system of drawing can sometimes lead to errors.

ture of the drawing. In these cases, where the model is composed of a large mass that defines the form and of other elements that help to enrich it, the blocked in sketch will be much more accurate if the lines of the sketch confine themselves to the main mass of

Preliminary Sketches

Sketching is often a means of experimenting until the artist feels sure of how to represent the model. Sketching allows the artist to "see" the model in different ways before embarking on the definitive drawing.

Two different versions of the same subject.

areas of light and shadow. This process omits all detail and intermediate values. This acts as a first "reading" of the drawing in which the areas of light and shadow can be laid out and later developed.

The Final Sketch

The sketch cannot be considered finished until the drawing begins to develop. Up to that stage, the variations the artist introduces may change the drawing completely, while on other occasions the sketch

merely requires reinforcing.

What began as a simple study using just a few lines can become an accurate point of reference for the development of the picture.

You can see from the blocked in study that the more the blocking is limited to the main structure, the more the form is defined and it is therefore easier to complete the drawing.

the subject as far as possible.

The sole purpose of blocking in a drawing is to help in the development of the drawing, so the more the lines fit the structure of the drawing, the more limited and more concise it will be.

Blocking In Shadows

When the model is strongly illuminated, another practical way of blocking in the drawing is to clearly establish the main

This drawing was done in two short stages: the forms were quickly blocked in and then intense lines, highlighted in white, were added. We may say that this is a finished sketch.

A quick sketch with shadows blocked in. No detail has been included; just the accents of light.

BLOCKING IN, STRUCTURE, AND SKETCHING

The process before developing the drawing consists of laying out a sketch of the subject within the confines of the space of the paper, using a set of lines that help to gradually construct the drawing.
Blocking in forms, developing structure, and sketching are three apparently similar processes, but with different purposes. They are all necessary for studying the model in depth.

Analyzing the Composition

Blocking in is representing the subject matter using the minimum number of lines. These lines must conform to the distances and proportions between the different objects of the model within the plane of the drawing.

The measurements used for

Transverse and longitudinal axes divide the space of the drawing, reducing the margin for error when positioning the objects.

the blocked in study are those of an imaginary pattern decided upon before starting to draw. In other words, if the artist decides upon a standard size for the model, all of the composing parts must correspond to this standard within the drawing. This imaginary pattern establishes a series of lines that make it far simpler to start drawing than when faced with a blank piece of paper.

Techniques with Different Media

The drawing medium you use does not determine the initial lines of the blocked in

Blocking in a tree to be painted in watercolors. This drawing is complete and includes no use of shadow whatsoever. It has been drawn in charcoal so that it can be easily erased.

drawing, as these are objective and superfluous later on, except in drawings where the initial construction is final. For example, the blocking in of a drawing that is to be painted in

watercolors makes no use of value changes while the lines are almost the final ones, indicating the planes of the drawing on which the blocked in sketch stands. This type of sketching should be easily removable to prevent it from being visible in the finished work.

Blocking In Forms Using Simple Lines

One practical way of blocking in a given subject is to draw a plan of the main forms within the framework of the picture, using simple clear lines to mark off the forms in geometric forms. For example, the overall form is first considered a pure geometric shape. The elements that compose this shape are then divided into other, simple geometric forms that gradually come closer to resembling the different elements of the model.

Geometric development of the forms of the model, fitting them into the space you have marked off.

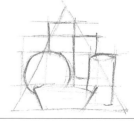

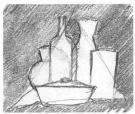

The forms resemble the model more and more until the layout becomes the basis for adding shading to the drawing.

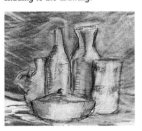

Analyzing the Structure of the Objects in a Composition

A good way of capturing the different objects in a composition in order to reproduce them proportionally on the paper is to try to see them as a whole, as a single abstract form.

If you half close your eyes when looking at the model, you lose the visual reference points that make the forms recognizable, so you tend to see the model as a whole, making it easier to analyze the drawing and the proportions.

If you observe the model with your eyes half closed, the overall volume of the forms becomes visible, making it easier to understand how to box it.

From Blocking In to Drawing

Blocking in and sketching are essential to drawing. Many good drawings actually cease to be so when they lose the charm and spontaneity of the sketch from which they were developed. Blocking in is a quick, initial vision of the model, so the drawing should always maintain some of these initial lines.

A drawing's basic lines can always be felt in a good drawing.

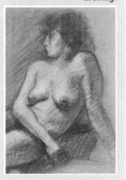

Quick Sketches

A subject can also be drawn without defining the lines but by simply drawing the overall shape and repeating this process until the correct shape begins to emerge.

This kind of stroke should be quick and spontaneous, trying to capture the composition and the proportions at the same time. This type of sketch makes it much easier to understand the forms of the model, which can be developed more fully at a later stage, using both the model and the boxing as a guide.

A few quick lines help to establish the initial phases of the blocking in.

MORE INFORMATION
• The geometry of objects **p. 14**
• Composition and sketching **p. 38**
• The sketch **p. 42**

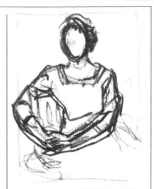

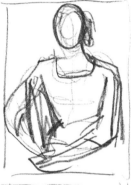

THE SKETCH

Drawing is a discipline that requires practice every day. Continuous practice at sketching
is the key to mastering representation in drawing. Different drawing techniques
appear in sketching, which covers the areas of space, volume, and line.
Sketching, we might say, is the daily workout for the artist's hand.
Sketching is a quick drawing with a view to developing it fully later on. After a good
session of sketching from life, one always learns more about how to master line and space.

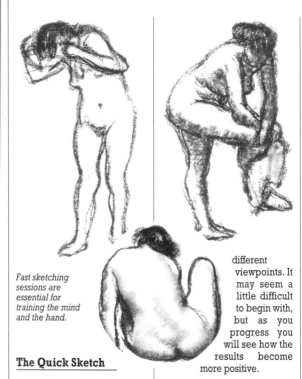

*Fast sketching
sessions are
essential for
training the mind
and the hand.*

The Quick Sketch

The aim of a quick sketch is
to capture a certain vision of
the model on paper. It is one of
the best exercises possible,
both for the brain and hand. If
the drawing is then continued,
this initial "snapshot" of the
model will help to analyze the
forms.

The only materials the artist
needs are a pad and a pencil,
as not even an eraser is
necessary. This kind of
exercise is best done in
several brief sessions, trying
to capture the model from

different
viewpoints. It
may seem a
little difficult
to begin with,
but as you
progress you
will see how the
results become
more positive.

Fast Drawing

A sketch can be developed
into a full-fledged drawing if
the artist decides to continue
with it. The artist's work here
consists of two phases:
capturing the model quickly
and spontaneously using just a
few main lines, and then
reworking the sketch until it
evolves into a study of
anatomy, portrait, or land-
scape.

There are several factors
here that determine the
success of a sketch. First we
have practice; the more the
artist practices sketching the
more skilled he or she
becomes. And then we have
the model, which can be found
anywhere; it is not necessary
to use a special place or
person as your model; any
part of the house, the street, a
person sitting on a bench or

*Any place is suitable for making
quick sketches or more
developed ones.*

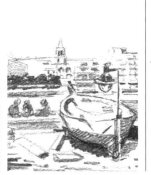

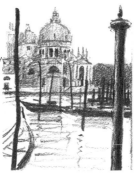

Several animals drawn in a single session. Several different views of the same subject should be captured in a short session.

Lines and Sketches

The lines and strokes used in a sketch should be spontaneous, a characteristic that is often lost when one elaborates upon a drawing. The pencil or graphite should create and construct at the same time, varying the pressure applied to produce different gradations of value that make up the planes of the sketch. This is one of the most enjoyable drawing techniques, as it does not need to be fully developed and finished. It is therefore a good way of acquiring the technique of representing reality.

A sketch of some boats and the different strokes that have been used to represent them.

walking down the street are perfect to use as models.

Sketching in Series

Sketches are of great help when it comes to mastering drawing, and it is advisable to practice them in series, that is, working quickly with hardly any corrections, capturing the model we have before us. The aim of this kind of work is to increase the coordination of mind and hand so that it becomes progressively easier to achieve a good likeness of the model. These series focus on a single model, such as a still

life, people in the street, animals, or a nude.

It is best to draw on a medium size sketchpad with a soft pencil or pure graphite, so that the lines are visible and will not need retouching.

Imagination and Reality

An important aspect of sketching is to distinguish between reality and what the artist has invented. Imagination can, on the one hand, be a useful factor when it comes to solving certain problems with composition, light, or simply to produce a given effect on the paper. On the other hand, it can form a barrier between the artist and the model. Sketches should never be done from memory; they should always be taken directly from the model and not from what the artist imagines.

Shading and Lines

A sketch can be realized from many different perspectives. A sketch can be understood as a series of washes that define the forms, or as a series of lines that enclose the forms without any type of contrast. Either type of treatment can be used depending on the artist's intention.

A sketch done using only lines, without any use of shading.

The same sketch of a portrait, represented as a contrast of values.

MORE INFORMATION

• Composition and sketching **p. 38**
• Quick sketches of animals **p. 44**

QUICK SKETCHES OF ANIMALS

Many artists take great enjoyment from drawing animals. Animals are, however, one of the most challenging subjects for drawing as their movements are unpredictable. This, then, requires an effort on the part of the artist to capture their likeness and constitutes an excellent exercise for training the hand.

The Structure of Forms

Animals, as with any other forms in nature, can be reduced to simple geometric shapes or groups of shapes, in order to synthesize the basic structure.

All animals, as well as humans, can be reduced to a series of simple lines. There are two steps to observing the animal you are going to draw. One is to block it in inside a simple, recognizable form, then transfer this form to the paper using a few simple lines. The second stage, which requires more attention and effort on the part of the artist, is to capture the space that surrounds the animal.

You must observe the animal closely and try to capture the overall shape.

All the elements in nature can be reduced to geometrical shapes.

This dog fits inside a triangle.

Fast Sketches

A session of quick sketching only requires a graphite stick, which can be used in two ways. The tip can be used for the lines, and the edge for thick strokes to shade in different areas.

Fast sketches are particularly useful for modeling shapes and the different parts of the animal's anatomy. With dogs, for example, the most difficult area to represent is usually the legs, but after a few sketches have been made, you will see how it becomes easier until you can draw them with a single stroke.

Graphite is useful for capturing the volumes and the shadows of the model.

Two possible ways of using the graphite stick.

Reducing Volume

The structure of different animals can be reduced to geometric shapes that are drawn in three dimensions. The basic lines of four legged animals does not usually vary: they consist of a truncated cone for the head and a cylindrical form for the body. The basic difference between the three-dimensional shapes of different animals lies in the neck and the length of the legs.

Varying the perspective of the geometric shapes helps to capture the foreshortening of the animal.

Precision and Mastery

The representation of animals in drawing can border on perfection. Great artists have considered animals as a reference point for the use of shading and proportion in drawing. Degas

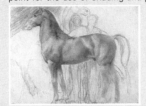

drew many animals and was so well acquainted with their anatomy that in many cases he did not even need to have the model before him.

Degas, Study of a Horse with Figures.

The Importance of Proportion

Drawing an animal, such as a dog, can be complicated if the dimensions have not been correctly calculated beforehand to situate each element with respect to the others. You can begin by judging the dimensions of the head as a guideline for the remaining proportions of the dog. In this case, if you study the figure closely, you will see that the total width of the drawing occupies a space equivalent to two heads.

The basic shapes of four legged animals are similar, reducing them to simple geometric forms: a truncated cone for the head and a cylinder for the body.

MORE INFORMATION
• Composition and sketching **p. 38**
• Blocking in, structure, and sketching **p. 40**
• The sketch **p. 42**

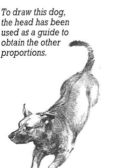

To draw this dog, the head has been used as a guide to obtain the other proportions.

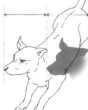

The width of the animal is the equivalent of twice the width of the head.

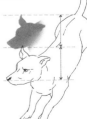

The length of the body is twice the distance between the snout and the ear.

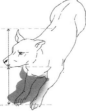

In the same way, the length of the head is compared to the paws in order to place them.

LANDSCAPES AND SKETCHING

Landscapes are an important subject for sketching. Sketches are often spontaneous, and can be made in any situation. One may come upon a good subject for a landscape sketch quite unexpectedly, so you should always carry a small notebook and pencil in order to draw a sketch at any time.

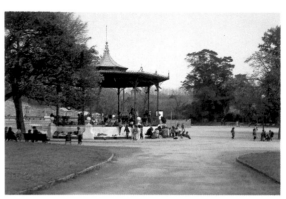

When choosing a subject, pay attention to the composition of the main areas and the contrast between them.

With graphite it is possible to obtain a gentle gradation from gray to black, depending largely on the type of grain of the paper. If the paper has little grain, the shading can be subtle; however, if you are using medium rough paper, it will be easier to create greater contrast of value.

The Scene and the Sketch

A landscape can be drawn from almost any scene, yet it should always have certain interesting features with regard to the use of light and shadow and the drawing itself.

These features include the possibility of creating contrasts, in order to produce a certain dynamism between the light and dark areas of the different forms.

A quick sketch can help you understand the theme.

Before actually beginning to draw, it is advisable to make a quick sketch of the main areas, which will be of help when it comes to the process of shading.

Shading Masses

After observing the model and making a preliminary sketch, you can begin to shade in the main areas with graphite, varying the pressure applied and filling in the gray areas and adding darker values by superimposing one stroke over another.

With graphite, soft values of grays are possible, such as this vertical shading.

The accents of darkest contrast help to establish the distances.

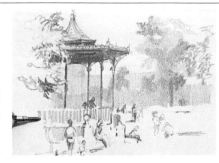

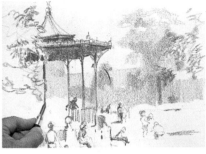

The foreground differs from the background in the increase of contrast and detail.

By giving people more detail in the foreground of the drawing and making them smaller as they recede into the distance, one creates the impression of depth.

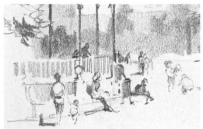

The addition of shading of the foreground is incomplete but is used to suggest the shapes of the forms.

Location of Contrasts

After the medium shading of the background, the contrast in the foreground must be intensified, increasing the sensation of depth with respect to the more distant planes.

This depth effect is shown in the illustrations in which you can see the difference in value between the nearest and furthest planes. The use of detail is increased in the foreground and in the center of interest, while the more distant planes are less well defined and less detailed. The small, distant figures in the background form a diagonal line, a suggestion of a line of perspective.

A Quick Study

Landscape sketches are easy once you have practiced them enough, together with sketches to capture the subject matter, the forms, and the perspective.

First, the basic lines of perspective are established, together with the background and the horizon line. Once the perspective of the planes has been obtained, the vertical planes are marked off, as well as the objects that can act as reference points.

Lastly, the planes in shadow are quickly reinforced with directional strokes.

MORE INFORMATION
• Composition and sketching **p. 38**
• The sketch **p. 42**

Blocking in lines of perspective and planes is essential in quick sketching.

The background planes merge into the whole with directional strokes.

From Sketch to Finished Drawing

A landscape sketch can easily become a finished work, such as the one you can see here that was developed using wash until this striking, finished work was obtained.

Ferrón, Urban Landscape, with felt pens and colored wash.

PERSPECTIVE IN ART

Perspective allows the artist to situate the different elements of the subject in depth by using vanishing lines. The correct use of perspective enables the artist to capture reality more accurately. The laws of perspective are applicable to any pictorial medium, although they basically belong to the field of drawing.
The use of perspective allows the artist to maintain the correct proportions between the figures, depending on their proximity, and can also be used to draw foreshortening in drawings of the figure.

One-Point Perspective

The basic factors in perspective are the horizon line, the viewpoint, and the vanishing points. The horizon line coincides with the height of the observer's eyes, irrespective of his or her position. This is independent of the height of the subject. The viewpoint is located on the horizon line. The vanishing points on the horizon line are the meeting points of the oblique, parallel lines with respect to the horizon.

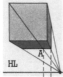

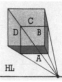

The horizon line is situated; a vertical line marks off the lateral plane. From the left vertex of A, the vertical line D is identical to B, and when joined to C completes the background.

Oblique Perspective

Unlike parallel perspective, oblique perspective presents different positions of the viewpoints and the vanishing points. This kind of perspective has two vanishing points. The two vanishing points (VP1 and VP2) and the viewpoint (V) are located on the horizon line. Under the viewpoint and the horizon line (HL), a vertical line marks off the corner closest to the observer. From the vertices of this line, the vanishing lines are drawn in to coincide with the vanishing points. The vertical lines marking off

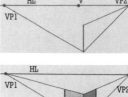

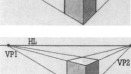

How to represent oblique perspective.

the two sides of the cube are drawn between the two vanishing lines of each of the faces, intersecting the upper vanishing lines that mark off the upper plane. Other vanishing lines are drawn toward the vanishing points, to complete the upper plane and finish the cube in oblique perspective.

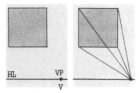

A cube is located above the horizon line (HL); in parallel perspective the vanishing point (VP) and the viewpoint (V) may coincide.

The perspective lines of a real scene.

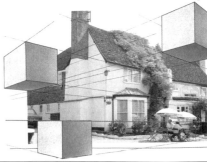

Applying oblique perspective to a real image.

*Perspective in the
Renaissance*

Perspective in the Renaissance

In the Renaissance, Humanist artists investigated perspective to such an extent that they wrote treatises that were applicable to the field of architecture.

Aerial Perspective

Aerial perspective is based on oblique perspective with the difference that it includes a new, third vanishing point that indicates the vanishing point of the vertical lines of the object. It is identical to oblique perspective up to the stage of situating the lines that mark off the vertical planes.

Guidelines for Drawing in Perspective

When drawing a model in oblique perspective, the vanishing points are situated outside the field of the drawing; however, there is a system that uses guidelines so that the lines do not run outside the drawing, allowing you to establish the perspective of the different planes correctly.

The subject matter is blocked in using the vertical line closest to the observer (a) and

A system for keeping the points of perspective within the drawing.

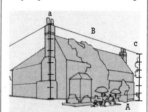

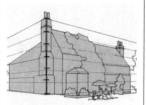

lines B and A are drawn that mark off the upper and lower areas of the model. On the vertical line (a), a series of equidistant spaces are marked that can be used as a unit of measure. This provides guidelines for dividing the sides on either side of the margins of the drawing (b) and (c). These will be divided into as many spaces as segment (a). In this way, guidelines can be drawn to place the main lines of perspective of the drawing.

Using Perspective

Using perspective correctly is important for achieving a realistic image. Obviously, it is not necessary to make complicated calculations to be able to draw in perspective. Nevertheless, you must bear in mind the vanishing points and the fact that objects appear smaller in the distance.

A sketch is sufficient for establishing the perspective of a drawing. Based on this simple diagram, the rest of the work consists of correctly adding light and dark values.

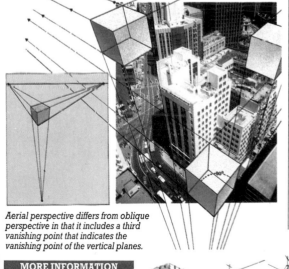

Aerial perspective differs from oblique perspective in that it includes a third vanishing point that indicates the vanishing point of the vertical planes.

MORE INFORMATION
• The geometry of objects **p. 14**

An example of perspective applied in practice.

LEAD PENCIL TECHNIQUES

The lead pencil is one of the traditional drawing media and the wide range of values it can produce make it one of the most versatile and practical media. The lead of these pencils is softer than graphite but less greasy, and produces a warmer stroke. Both graphite and lead and other drawing media have a series of techniques in common, the difference lying in the hardness of the medium used.

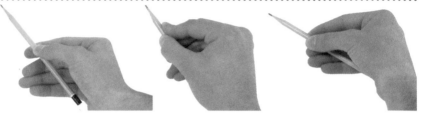

Different ways of holding a pencil, depending on the artist's requirements.

Holding the Pencil

Knowing how to hold a pencil is one of the main factors a draftsman must bear in mind. The hand should be comfortable and free from any rigidity, either in the fingers or the wrist.

There are two basic ways of holding a pencil. The first is almost the same as for writing, but the artist holds the pencil further up to allow for the movement of the wrist and the fingers. This position allows one to apply continuous lines, without lifting the pencil from the paper.

The other position is with the pencil held inside the hand, as in the illustration. This allows you to make quick values, sweeping lines, and intense tones. This position is generally used for large format drawing, as it is unsuitable for small format drawings.

Basic Lines

When using pencils, you must bear in mind the different types of lines they produce, depending on the tip and how it is applied to the paper.

A pencil sharpener can be used to sharpen the tip of a pencil but make sure it produces a long, pointed tip. A knife can also be used, allowing you to decide the length of the tip.

A normal tip held almost perpendicular to the paper produces a medium line, yet if it is slanted, the surface touch-

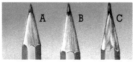

Different kinds of tips:
A. Incorrect; the pencil sharpener was too short.
B. Correct; a long pencil sharpener.
C. Tip sharpened with a knife.

ing the paper is greater and the line therefore thicker.

Gradations

Lead or graphite pencils can produce gradations of value. The texture of the paper determines the results of the gradation.

The effect produced by different tips.

Perspective in Art
Lead Pencil Techniques
Conté with White Highlights

Values made with a number 2B pencil (above) and with a hard H pencil (below).

Gradations are realized by gently stroking the paper with the slanted pencil, beginning with a constant pressure and drawing in zigzag fashion. The pressure should diminish until you have a series of values that range from the darkest black to the lightest tone the pencil will produce.

The numbering of the pencils indicates the intensity of the gradation you can obtain.

Vertical Shading

Vertical shading should be done in much the same way as slanted shading. It should be done firmly, to avoid varying the plane.

One of the most common ways of shading a large area is to use even, vertical strokes of the pencil, because otherwise the hand tends to produce a slanted effect with respect to the horizontal plane.

Slanted Shading

Shading is used to cover a surface with an even tone. Shading is obtained with directional strokes and applying the same pressure to produce an even texture.

Vertical shading using short vertical lines.

Slanted shading is done at an angle to the horizontal line of the picture.

This kind of shading should be firm and steady and this is one of the most important factors when drawing.

Circular Shading

This involves drawing small circles in order to obtain an atmospheric gradation. You begin with small circles drawn

Slanted shading.

spirally that occupy the entire surface little by little, varying the pressure applied with the pencil in order to achieve the effect of a progressive gradation.

Shading using circular spirals.

Applying Strokes

This requires a good deal of practice, as in drawing figures are modeled by the type of strokes that form the different values. The strokes of the different values are applied, following the direction of the plane on which they stand.

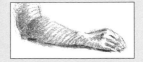

The strokes used for the gradation of these figures follows the plane of the surface.

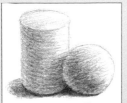

MORE INFORMATION
• Pencils: hardness and qualities **p. 26**
• Stumps **p. 30**

CONTÉ WITH WHITE HIGHLIGHTS

Conté is one of the traditional drawing media. Its warm, opaque quality means it can be used to draw on colored surfaces, with the advantage of being able to contrast one tone or color superimposed over another.
Conté can produce a sense of volume that is not so readily obtainable with other media such as graphite or lead. Conté is easily blended, and white highlights can be added when colored paper is used.

Chalk and Conté

Chalk is limestone mixed and bound with glue. It can produce dense and opaque lines and can also be gently blended. Chalk is considered one of the most limited of color ranges as it only includes sienna, sanguine, and dark blue, just enough for producing highlights on colored paper. Assortments of colored chalks are available on the market, which imitate pastel colors, yet artists use those colors mentioned first.

Conté is composed of iron oxide and limestone bound with gum. It is harder than chalk and comes in sticks or pencils.

Starting the Drawing

The technique with Conté is no different from other drawing media, although because the colors are warm and opaque it is ideally suited for use on colored paper, even dark colored paper. All other drawing media such as charcoal and graphite are only suitable for light colored paper.

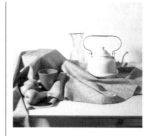

After observing the subject, the sketch is drawn, defining the main areas with the edge of the sanguine Conté. The forms can be accurately blocked in using simple geometric figures.

1 2 3

4 5

Conté pencils:
1. white;
2. dark sienna;
3. sanguine;
4. & 5. lead for Koh-I-Noor 5mm diameter propelling pencil.

Conté crayons:
6. sanguine;
7. dark sienna;
8. white.

6 7 8

First the subject is lightly blocked in, drawing in the main shapes and without indicating the values. Each of the elements of the model is drawn with the Conté held slanted for small areas or held flat for longer lines.

Defining the Masses

When the initial scheme has been correctly established it is always easier to define the forms. In this example there will be two main areas of light and shadows, and two main intensities of shadows.

The tip of the Conté is used to drawn diagonal shadows, and the edge is used for general shading, increasing the intensity of the tones in the darkest areas.

Blending Conté is also easy, and can be done with a cloth.

Shading

The artist often wants to keep the color of the paper visible in certain areas. In this way it is easier to modify the different values. Sanguine Conté blends much better when colored paper is used. One of the most effective ways of analyzing the different tones is to half close the eyes and try

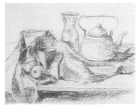

To define the shadowed areas, the tip of the Conté has been used for the lines and the edge for the large masses.

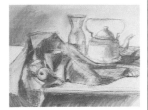

The shadows are blended using a cloth, pressing firmly on the darker areas.

MORE INFORMATION
• Modeling a figure in Conté **p. 76**
• A portrait in Conté and charcoal **p. 78**

The First to Use Conté

Most art historians agree that the first person to use Conté as a drawing medium was, without a doubt, Leonardo da Vinci, around 1500. Leonardo would constantly experiment with technical media both in drawing and in painting. It is hardly surprising, therefore, that he should have made his own drawing media, as he did with his painting media.

to see the tonal masses as if they were superimposed. As white highlights are to be added later, the Conté tone should cover everything and leave few white spaces.

Highlights

When you have completed the shading, increasing the intensity of the contrast by adding new lines of sangine over the areas that were blended previously, you can begin to add white, especially in the most illuminated areas of the drawing. Highlights are more effective when used sparingly, just in those areas that require a sharper contrast

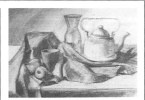

When shading with the Conté, the tones obtained should cover the entire drawing, leaving only a few blank spaces, yet letting the color of the paper show through.

and volume. It can be applied in different ways: by using lines that follow the direction of the plane, by adding small points of light, or by drawing the flat stick over a specific area to increase the overall luminosity.

These highlights have been applied in three different ways: drawing lines, using the flat sanguine Conté crayon, and using the tip very precisely on spots of maximum brightness.

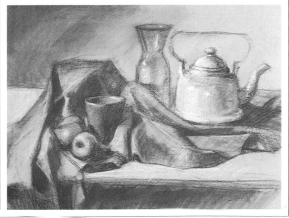

DRAWING AND WATERCOLOR

Watercolor is the most transparent pictorial medium that exists. It therefore requires a carefully drawn study on which to apply the different glazes.
Drawing and watercolor are combined in the technique of using a dilute watercolor wash, usually a neutral color, to block in the work.

In watercolor the underlying drawing is always visible. In these two examples you can see how the drawing outlines the brush strokes.

The Basic Drawing

Drawing is one of the media closest to watercolor. In fact, watercolor could not exist without the structure of the drawing that acts as a guideline.

Drawing is fundamental to watercolor in the construction of the painting. The transparency of watercolor requires a guide for the different planes of the shapes, so that the artist can situate the planes of color and the different brushstrokes without fear of making a mistake.

Preparatory Drawings for Watercolors

When working on a drawing that is subsequently to be painted, great care should be taken both when observing the model and when synthesizing the shapes of the model. Only the essential lines should be drawn, omitting any lines that are not entirely necessary. Each of the planes of the drawing must be analyzed separately. The lines of a preparatory drawing for a watercolor painting cannot be changed later.

The drawing has to be a perfect guideline to be developed later using color, while the synthesis of the different planes should capture their position without including any shadows or variation of value.

Different Subjects for Drawing

Landscapes in watercolor require sharp lines to separate the different planes without adding any volume. The areas of light and shade must be clearly established from the beginning.

A still life in watercolor follows the same method, but should be more concise, basically due to the added detail.

A landscape is observed from a distance; forms are recognizable yet not detailed. On the other hand, a still life is close to the artist so the shapes must be more defined.

MORE INFORMATION
• Composition and sketching **p. 38**
• Wash **p. 58**
• Practicing with ink **p. 86**

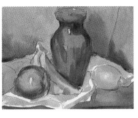

When drawing a still life, the forms should be more detailed.

Drawings that involve great use of detail such as figures or animals require a more definitive approach, setting out clearly where the different colors and the light and dark areas are to be situated, so that the color is later applied correctly.

Drawing that involves a great amount of detail must be as defined as possible, with attention to each of the different planes.

Drawing in Wash

Wash is a monochrome treatment with ink or watercolor. In neither of these techniques is wash considered to be a true pictorial treatment, but rather a method somewhere between drawing and painting. The approach to wash is that of drawing, with the use of a preparatory sketch that is perhaps in another technique such as pencil. Or the forms can be defined directly, using monochrome masses and lines drawn with a brush, which, when dry, will show through. If the wash is superimposed before the lines dry, it may blend into the whole.

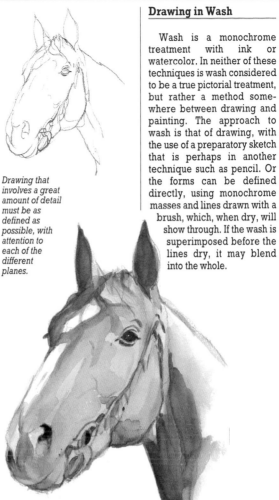

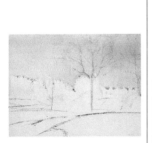

In this drawing we can see each of the areas of light as well as the different planes in the composition.

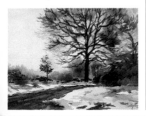

Kandinsky: Drawing, Watercolor, and Abstraction

In 1910, Wasily Kandinsky painted the first abstract painting in the history of art. He used watercolors for this pioneering work. Kandinsky (1886–1944) produced a large number of totally abstract drawings that were published in 1952 in his work *On the Spiritual in Art* in which, among other things, he reflected on abstraction in art and possible parallel aspects in music.

Kandinsky, "First abstract watercolor," 1910.

FELT PENS

Felt pens, like other drawing instruments with a felt or nylon tip, are ideal for drawing and virtually become a medium in their own right given their quality and potential for expression. Being soluble both in alcohol and in water, the drawing takes on a pictorial dimension, without ceasing to be a true drawing.

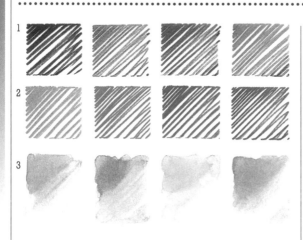

Range of colors for felt pens and their effects when diluted with alcohol or water, depending on which solvent they require. (1) & (2), Felt pen directly. (3) Felt pen brushed with water.

Gradating and Blending

Two colors from the same chromatic range can be blended together provided the pens of are good quality and have sufficient ink.

Blending should always be done wet on wet, that is, before the underlying color has dried. Gradation is always carried out on the lightest color, adding a darker stroke and

Gradating with a felt pen. You always start with the lightest color, adding darker tones while still damp.

Techniques

Felt pens are not considered a true pictorial technique because they are differentiated by certain characteristics such as the tip (although there exist good quality pens with a brushlike tip) or the way they are handled. They can, however, be used to good pictorial effect. Felt pens offer

a wide range of possibilities: from being used as a purely linear technique like any instrument using ink, to producing large areas of color and other common pictorial techniques such as wash, values, and blending, to superimposing planes, as well as the creation of planes using the tip of the felt pen itself.

Felt pens offer a great number of possibilities for drawing. Being soluble in water or in alcohol, they can produce a wide range of technical effects.

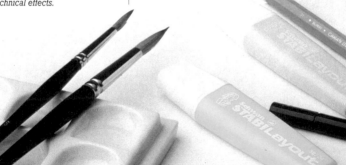

Special Uses of Felt Pens

Their characteristics make felt pens ideal for drawing, although they also have a potential for creating a highly plastic form of expression. Drawing with felt pens does not merely involve lines, but also manipulating, blending, and superimposing them over other colors, as a purely pictorial means of expression.

Felt pens produce a line that combines with washes and the superimposition of different planes, as shown in this landscape.

reducing the intensity of the color as the tone is gradated. As the base color is damp, the darker tone will blend with the underlying one, spreading over any areas that are to be intensified or darkened.

Another way of gradating is by starting with a special, neutral felt pen, which is used solely for removing color and can be used both for gradating and for blending.

Superimposing Planes

A felt-tip pen can be used for superimposing colors to create planes of great transparency. The pen can be applied as if superimposing color filters over the underlying colors, with the resulting chro-

MORE INFORMATION
• Drawing with felt pens **p. 32**

matic effect. As superimposing planes add different colors to the underlying planes, you should refresh your knowledge of color theory to foresee how the colors will interact when mixed.

To produce a continuous plane free of tonal variations with a felt pen, the plane must be painted using even, parallel, superimposed bands of color. This way the base color can be obtained and when dry, can be painted over with the desired color, again using superimposed, parallel lines.

Superimposing planes with lines. Superimposing planes with a felt pen is the equivalent of mixing colors on a palette; so if two primary colors such as blue and yellow are superimposed, a secondary color, green, is the result.

Covering a Surface with Parallel Lines

Applying broad, parallel lines with a felt pen is one of the most common ways of covering large areas. This system saves time and avoids unnecessary wear of the pen, because when drawing in zigzag or circular fashion, the color is not only uneven, but the pen wears out more quickly as the artist paints over areas already colored.

Felt tips come in all sizes and different qualities, from the classic conical felt tips to a whole range of different sizes and materials. When we wish

Parallel lines can evenly cover large areas, provided you have chosen the right kind of tip.

to cover a large area with a particular tone, it is important to choose the right size tip (some marker pens have tips almost an inch in diameter) and to apply parallel lines and superimpose the edges.

Sweeping Strokes with the Felt Pen

Sweeping strokes are another of the most common ways of creating planes with a felt pen. This is the name given to the effect produced when the lines follow the "rhythm" of the plane, reinforcing and highlighting it. A cone-shaped figure, for example, would be drawn by using sweeping, almost circular lines that follow the curved plane of the figure.

Sweeping strokes always reinforce the plane they form, as you can see in the sample; a series of concentric planes are drawn following the radius of the thick lines that form it.

Sweeping strokes are used for the lines following the plane of the figure.

WASH

In watercolor there is one technique that is closer to drawing than painting because it has the same characteristics that we see in drawings: a monochromatic color scheme, contrast of light and dark, and a combination of line and form. A wash is perhaps the pictorial technique that is closest to drawing, the only difference being that it is a wet medium, able to take advantage of watercolor techniques. A subject can be represented in much the same way when using a wash technique as when using a drawing technique. One can use a brush for washes and a pen for a purely linear treatment, combining the two techniques.

After analyzing the subject, the forms are drawn using only lines and eliminating the addition of different values for the moment.

Blocking In Forms

A wash starts with a completely transparent background, always working from light to dark, that is, additional tones are added to the lighter colors and never the reverse. This is why it is essential to decide from the beginning which parts are going to be the main areas of the drawing and consequently the gray values that will be used for each of these areas.

The subject should first be analyzed from the point of view of the composition, without concern for contrasts of values. A pencil having the same tone as the wash should be used, blocking in the shapes and planes on the paper as precisely as possible.

The aim of the first wash is to modify the background color and prepare the drawing for the subsequent addition of different values.

Modifying the Background

A wash always starts with lighter tones that are darkened as the work progresses. The reverse, that is, working with a light value over a dark value, is not possible, so the initial tone will form a light base for the drawing.

A wash is always mixed first on the palette and then tested on paper of the same quality to avoid any mistakes that would be impossible to correct later.

This initial wash will form the basis for the following tones, and the areas that will contain the whitest or most luminous tones should be left untouched.

Shading with Brush and Drawing

In the following steps, the gray tones bring out the forms of the buildings, as if they were

The first wash distributes the first values and leaves areas untouched that are to contain the lighter tonalities.

A Three-Color Wash

A work in one or two colors of ink is considered a wash, yet we must bear in mind that if two primary colors are used, the result of mixing them will produce a third color to enrich the tones and chromatic range. And in addition to these we have the base color of the paper, adding yet another color, usually the lightest of those used.

boxes. Always bear in mind which areas are more luminous and which are darker in order to add the darker values later.

Knowing how to handle the brush correctly is of great importance when working in wash, because, although it is classed as a drawing technique, the use of wash, value changes, and line are the result of brushwork. If a "broken" brush stroke is required, the background must be completely dry and there should be very little paint on the brush. This allows a dry brush stroke broken by the background color.

Watercolor Technique

Wash owes a great deal to the watercolor technique. Yet the way in which it is used as a monochrome technique and its

Shading of different planes using wash.

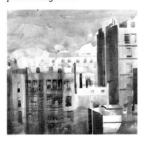

Drawing with a pen or, in this case, reed-pen and ink, sharpens the contrast of value and tone and emphasizes the darker tones.

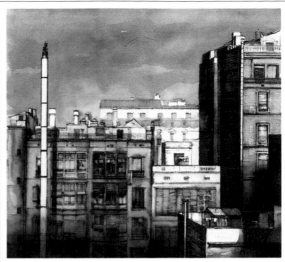

A value study in wash is combined with the pure linear quality of drawing. Notice how, on the darker walls, the direction of the lines creates a sensation of perspective.

tonal treatment place it on the same level as drawing. Drawing also owes a great deal to watercolors: the transparency, the medium itself, and the use of white or light areas.

Using wash in this way brings it close to chiaroscuro, the suggestion of the volume of the shapes by the sweeping, darker lines. The lines representing the plane of a wall shown in perspective, for example, lend this sense of perspective to the subject.

Opening Up White Areas Instead of Erasing

In dry drawing techniques, the eraser is used not only for correction but also as a drawing instrument. With wash, the eraser is not used, yet we often

MORE INFORMATION
• The sketch **p. 42**
• Drawing and watercolor **p. 54**

Using a water and 50% bleach solution, clean white areas can be opened up.

need to open up white areas to reinforce highlighted or light areas.

There are three basic methods for achieving this: one is by blotting the wet wash, and thereby lightening the area with a dry brush or even absorbent paper. Another system is over a dry wash; the area is dampened with a brush and gradually erased by removing the wash. And the third method is by using water diluted 50% with bleach. The area to be whitened is "painted" with this mixture and will eventually turn completely white.

LINE AND WASH WITH DRY OR GREASY MEDIA

A drawing is constructed by the lines that form the structure of the subject. There are many different ways of using lines depending on the artist's intentions.
Each of the different media used in drawing produce a different type of line: even lines by applying different degrees of pressure, heavy or delicate lines...everything depends on the medium and the artist's purpose.

The different qualities of the paper used determine the results you can obtain with different media.

A drawing using a thick reed-pen and ink.

Paper and the Drawing Medium

Paper comes in many different types and qualities that vary depending on thickness and weight; on the absorbency of the surface; and on the texture, which may be rough or smooth.

The same medium, be it charcoal, graphite, Conté, or pencil, will produce different results depending on the paper used. For example, if charcoal is used on varnished cardboard, the lack of porosity means that the medium will be rejected. A grease pencil, on the other hand, adapts perfectly to this surface.

Greasy and Dry Media

Drawing is based on knowledge of the potential and limitations of the medium as to tonalities, blending, and values.

Media can be divided into greasy or dry. Greasy media include graphite and greasy lead, including water-soluble wax

Different dry media: 1. Artificial compressed chalk; 2. & 3. Faber artificial compressed charcoal; 4. Conté artificial compressed charcoal; 5. Koh-I-Noor charcoal and clay; 6. Special Koh-I-Noor charcoal and clay propelling pencil; 7. Willow, vine, and walnut charcoal, in pencil or stick form.

pencils. Dry media are derived from charred woods and minerals, such as charcoal, charcoal pencils, and chalk.

Both greasy and dry media produce firm lines, although the dry media are not as stable and require protecting or "fixing" with special spray fixatives. The softer the medium, the more unstable. Dry media are easier to erase and correct using an eraser or a piece of cloth.

There are different kinds of paper, some best suited to grease pencils, others to pastels, available with different types of grain and absorption qualities.

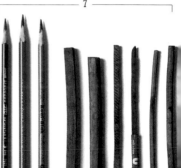

1 2 3 4 5 6 7

1. Grease pencil application;

2. Graphite pencil 9B;

3. 2B pencil;

4. Lines drawn with a felt pen.

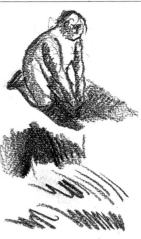

Grease pencil on illustration board. Very stable, but it cannot be blended.

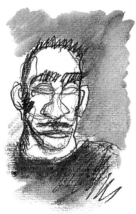

The water soluble black pencil can be used not only as a drawing technique but also to produce washes.

Lines and Hardness

Variations in the quality of the lines may depend on the hardness of the chosen medium; the softer the medium, the more intense the darks. With ink, dark areas are obtained by cross-hatching and by the different density of the lines.

In artistic drawing it is always advisable to use soft media so as to be able to produce dark blacks or shading of great tonal wealth.

The adjacent illustrations show the different intensities of gray obtained with a grease pencil, which is the hardest; and with a 9B lead pencil, a 2B pencil and a felt pen.

Lines, Planes, and Blending

Lines are the basis for constructing a drawing. Lines should never appear hesitantly drawn, and if lightly drawn only if this is what the drawing requires, not because the artist feels apprehensive. Decisiveness is all important in drawing, and retouching lines should be avoided whenever possible. It is better to use long continuous lines rather than many short ones to define a shape.

As a whole, these lines represent planes, yet each plane should be different from the rest in order to be easily distinguishable. Each plane should therefore be treated

MORE INFORMATION
• Lead pencil techniques **p. 50**

with the required intensity with respect to the overall construction of the drawing.

Blending extends a gradation of value over a certain area and can be achieved using your fingers or a stump.

Planes are formed by drawing lines in the same direction.

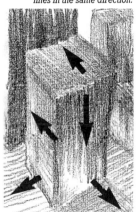

Spontaneous Lines

To practice drawing lines, it is not necessary to spend long sessions as one should when drawing the subject. Any situation can produce fine results, and a small exercise can be done on any handy piece of paper—a paper napkin or an odd envelope when having coffee.

A. R. Márquez: Drawing on an envelope using a 2B pencil.

TECHNIQUE AND PRACTICE

CORRECTING MISTAKES IN DRAWING

Mistakes occur frequently in drawing; the artist completes a work and at the last moment realizes that it contains a mistake that had previously gone unnoticed. On many occasions the necessary correction consists merely of erasing the mistake, yet sometimes it requires a thorough comparison of the first placement of the subject matter on the paper, the subject matter itself, and the final drawing.

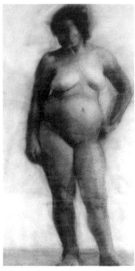

In this drawing a kneaded eraser was used to bring out the light areas that emphasize the modeling of the body.

Here an eraser was used as a drawing instrument, opening up white lines that reflect the movement of the figures.

Erasers

Erasers are useful not only for correcting mistakes but also for creating white areas. Each medium requires a certain kind of eraser. Charcoal is easily removed with a kneaded eraser while ink requires a hard plastic eraser.

Erasers are often used to change or modify the areas between light and shadow, opening up white areas when the drawing has been overworked and has lost its nuances and contrasts. Alternating the use of the eraser and blending, the drawing regains the sensation of volume.

MORE INFORMATION
• Stumps **p. 30**
• Charcoal techniques **p. 82**

Correcting Mistakes Without Erasing

A drawing undergoes constant changes as it is developed, to the extent that the initial blocking in is merely a guide and the artist is constantly retouching and refining the lines that create the different planes and forms.

As the drawing takes on its more definitive form, lines are

The drawing has been corrected without erasing the lines of the initial sketch.

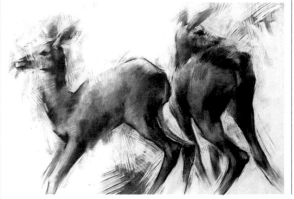

superimposed on others in a process of continuous correction, until the definitive shapes appear. All of this is done without resorting to an eraser. It is often necessary to make a last minute correction, even though most of the drawing has been properly developed, and if it can be corrected without erasing the result is often more interesting. Frequently the resulting series of lines becomes the main expressive element of the drawing.

Corrections in Sketches and Final Drawings

A drawing that requires a faultless finish also requires careful correction. Some of the lines used to block in the structure of the subject may be removed as the work pro-

Charcoal is easily corrected with a simple pass of a rag.

gresses, as well as after the artist considers the drawing finished.

In these cases an eraser is essential to remove only the part that requires correction. The harder the eraser is, the more it affects the paper; so correction depends as much on the eraser as on the thickness and texture of the paper, as well as the medium used for the drawing.

Different Drawing Media and How to Correct Them

Each medium calls for a different kind of correction. Charcoal can be removed using a piece of cloth or, if a white area needs opening up, with a kneaded eraser. Graphite, both in stick and pencil form, can be erased using a ball, cleaning it between uses. Graphite is also soluble in turpentine, so if the tip of the pencil is dipped in turpentine, stronger lines can be produced. In addition, a wash can be created with a brush and turpentine applied to a graphite drawing.

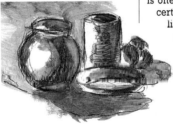

An eraser can be cut at an angle to carefully open up white areas within the charcoal drawing.

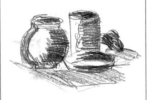

Charcoal, a Medium for Studies

Charcoal enables the artist to control the work and to correct it easily using a piece of cloth and then blowing to remove any excess dust. It is one of the most suitable media for making studies in drawing of almost any subject. When working in charcoal an eraser is often used both to "clean" certain areas and to bring to life those parts of the drawing that require stronger lighting.

This still life sketch has been corrected and finished by applying a brush dampened in turpentine. Graphite dissolves easily in turpentine and can then be shaped and modeled using the brush.

This drawing reveals an obvious error in the construction of the profile and nose. The entire area has been erased and reconstructed properly.

SHADING

Shading is used to establish different areas of volume of the bodies by using light. Shading consists of placing different values of gray tones in such a way that they emphasize the modeling of a form and create a three-dimensional effect.

Different drawing media differ in the techniques used to achieve subtle shading of the subject matter. Sometimes graduated shadows are possible, sometimes blending works, and sometimes cross-hatching is best.

Traditional drawing techniques require an elaborate process of shading.

Different Ranges of Value

Shading is possible because a single pencil is capable of creating a wide range of values, although each degree of pencil hardness has a potential for certain values, from the deepest black to the lightest gray.

Different hardnesses therefore have their own limitations, so whenever introducing shading in a graphite drawing, it is advisable to have several pencils at hand in order to be able to produce a greater wealth of tones and not confine oneself to a given hardness.

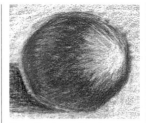

Every drawing medium has a specific capacity for shading. Sanguine Conté, for example, can be combined with chalk or charcoal to increase the effect of the shading.

This drawing shows how the shading has been used to model the forms, while the most brilliant areas of light indicate the plane and the direction of the light.

The values each pencil can produce are limited. This first scale has been drawn with a very soft 9B pure graphite stick.

The different values of gray must be considered when working on the shading of a drawing. The effect of simultaneous contrast makes a light value appear lighter if adjacent to a very dark value, as occurs in this example. The medium values are identical, yet appear different with the addition of the darker tonalities.

Shading and Value

Shading consists of establishing a range of values so complete as to lend the model volume. These different values always start with the color of the paper, unless colored paper or chalk relief are used.

Darker values indicate the maximum volume while light areas reflect the nearness or the direction of the light source.

The play of simultaneous contrasts should also be borne in mind when shading, as the same value of gray varies depending on the intensity of the darkest adjacent tone.

Blocking In a Value Study

Blocking in a value study consists of a synthesis of the major shapes of the model. The values should be established from the beginning by shapes that define the different planes.

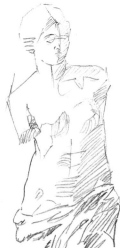

This could be a sketch blocked in for a value study in which the planes of light and shadow have been separated and have been indicated by a directional stroke of the plane of the darkest areas to bring out the volume.

Using this overall scheme, the main shapes and most important shadows are introduced as planes.

Blocking in a composition is the first step in indicating the principal masses and shadows of the drawing. So in a value study, a detailed drawing is carried out of the areas that require special care with shadows. There are many ways of blocking in shadows of the main forms, but one way is to separate the lightest areas from the areas in shadow, including the intermediate grays.

Light and Shadow in Ingres' Work

Jean-Auguste Dominique Ingres (1780–1867) could be described as the main representative of classicism. His work is marked by the use of delicate lines and a sharp sense of modeling. Yet what really makes Ingres such an outstanding draftsman was his great sense of proportion and value.

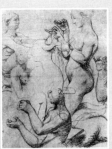

Jean-Auguste Dominique Ingres, Study for The Turkish Bath.

Defining the Range of Values

As we have seen, developing the range of values of different media is especially important in value studies. The artist must be aware of the possibilities of the different hardnesses of the pencil or graphite being used. These are then used to apply the different degrees of shading (the gradations dealt with earlier) within the context of the drawing.

This drawing allows you to see how the different range of values is applied in practice. The foreground was drawn with a very soft lead pencil, a 9B. The lighter values in the same area were drawn using a 4B. A 2B was used for the background while the buildings that are just visible were drawn and shaded in with a 2H.

MORE INFORMATION
- Pencils: hardness and qualities **p. 26**
- Chiaroscuro **p. 66**
- Modeling a figure in Conté **p. 76**

Creating Form by Shading

Using our knowledge of the effects of the different values, it is not only possible to create planes within the drawing but also to suggest the volume of the forms. First the main shapes are suggested, that is, blocked in without adding any shading to them; then the different volumes are situated introducing light shadows and finally all the light and dark areas of the painting are placed. Areas of maximum contrast are developed, and highlights are opened up with the tip of the eraser.

In this quick study of a plaster model, the shading suggests the form by using highlights and by increasing the contrast of the figure against a very dark background.

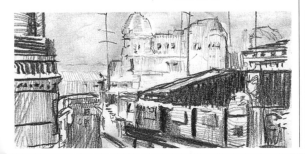

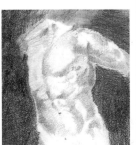

CHIAROSCURO

The aim of chiaroscuro is to represent objects by using and developing the areas of light and shadow as a simultaneous contrast of tones. Modeling forms with light is an exercise that requires great attention to tonal differences and the effect of the gradations of different values. Chiaroscuro not only involves modeling shapes but also important changes of light in the composition of the drawing.

Shading and Chiaroscuro

Chiaroscuro is a method of shading that affects not only the main element of the drawing but every element in the picture. How each of these different elements are shaded always depends on the placement of the model with respect to the light source. Chiaroscuro requires a thorough analysis of the model and the lighting. In this kind of value study, the same method of

A chiaroscuro effect is produced by placing an object before a strong source of light. Each method of shading is different depending on the type of light:
A. Drawing an object illuminated with electric light.
B. Drawing an object illuminated with natural light.

A

B

gradation cannot be used in all the planes of the drawing as each of them is illuminated in a different way. The foreground may receive the light laterally, while the middle area may receive only part of the light that bounces off the foreground and therefore requires a lighter value and less contrast than the foreground.

Blocking In Values

A drawing emphasizing chiaroscuro requires that the shapes of the masses be accurately blocked in. Although many of the elements in chiaroscuro seem to be part of the area in shadow, some of them are strongly illuminated, or at least appear to be so due to the contrast of lights. The area that contrasts with the shadows is defined not only by the lines that show the visible areas; blocking in a work in chiaroscuro must be general, although these lightly sketched forms will later be shaded so that they merge with the background.

Lighting in Chiaroscuro

When shading a model in chiaroscuro, one must consider the background and the light source. Yet this light is not evenly distributed over the entire surface of the object; it is distorted and bounces off differently after striking the foreground of the model.

The blocking in sketch of this portrait in chiaroscuro lends structure to the entire drawing, although most of it later fades into the penumbra.

Alternating tonal areas.

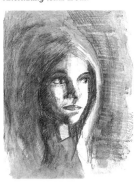

An electric light in front of a model produces sharp, well-defined shadows. Diffuse light comes either from a natural light source or reflected electric light, producing soft, edgeless shadows.

The Law of Simultaneous Contrasts

When drawing in chiaroscuro, it is necessary not only to use correct shading of the model to establish the different planes of light and shadow. It is also important, in order to underline the chiaroscuro effect, to follow the law of simultaneous contrasts. This effect helps to define the darkest tones of the model. The law says that a light tone appears lighter against a darker surrounding shadow.

Making use of simultaneous contrast in chiaroscuro is very useful because when an element in the foreground receives a certain ray of light and the background tends toward an even black, the distance directly affects the tonality of the elements appearing in the receding planes.

The law of simultaneous contrasts is especially useful in chiaroscuro; a light tone appears lighter the darker the surrounding tone.

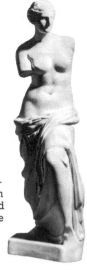
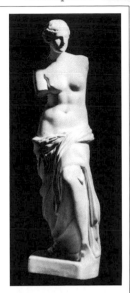

Chiaroscuro in the Baroque Age

From Caravaggio on, the chiaroscuro technique became a feature of the Baroque style. Great masters such as Rubens, who possessed a fine sense of color and light, made modeling forms in chiaroscuro a means of expression in its own right, bringing volume and an almost sculptural effect to this drawing technique.

In this charcoal drawing, Rubens shows his mastery of form, light, and space.

Peter Paul Rubens, The Fall of the Damned, *charcoal drawing.*

Modeling a Drawing with Chiaroscuro

The following factors must be borne in mind when modeling the drawing: the light; whether it is direct or indirect; the highlighted area, which is the effect resulting from the contrast between a light and dark area; and the shadow of the object itself, which does not receive the light directly and which can be divided into the darkest shadow, chiaroscuro, and reflected light. The darkest part of the shadow lies between the reflected light and the lighted area; the penumbra is situated between the lighted area and the darkest shadows; the shadow is that of the model itself.

MORE INFORMATION
• Pencils: hardness and qualities **p. 26**
• Lead pencil. techniques **p. 50**
• Shading **p. 64**
• Charcoal techniques **p. 82**

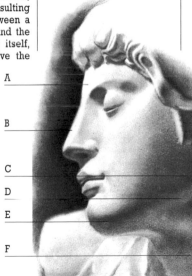

Factors to consider when modeling a drawing in chiaroscuro: A. direct light; B. highlighted area; C. shadow of the object; D. reflected light; E. darkest shadow; F. penumbra.

ATMOSPHERE

One of the most interesting effects you can achieve by a careful use of value is in creating atmosphere. The different values in a picture vary in proportion to their distance with respect to the observer. When all of the different planes of the drawing have been properly shaded, the work takes on a certain atmosphere, using values of different intensity depending on the range of values in each plane.

Defining the Drawing with Planes

Atmosphere is perceived by the comparison between the different planes of the drawing. In other words, each plane has a certain definition; if the artist wishes to create atmosphere, he or she must apply a different tonal value to each plane in the drawing. Atmosphere cannot be created using just one value for all the planes of the model. This impression of atmosphere not only affects the shading of the different planes. As is to be expected, variations in value result in a loss of definition in the drawing as the more distant planes are added.

This lack of definition can be the result of different factors: essential lines become vaguer as they recede into the distance; blending softens the lines of the more distant planes, or they can be diffused using softer values as the planes retreat.

Establishing Planes and Values

Each plane should have a particular value depending on the atmosphere the artist intends to create. These planes can be situated by establishing reference points using the darker tones. For example, in order to underline a series of planes, we first choose the area occupied by the foreground and develop it using "soft" shading. The more distant planes are treated in the same way to produce an atmosphere that becomes more dense as the drawing recedes.

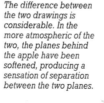

The difference between the two drawings is considerable. In the more atmospheric of the two, the planes behind the apple have been softened, producing a sensation of separation between the two planes.

These effects can be achieved using an eraser or by simply blending. The atmosphere is created by the subtle difference between the planes.

Variations in Lead and Tonal Gradation

Tonal gradation is largely dependent upon the hardness of the pencil. Atmosphere in a drawing can be achieved much more effectively if, after establishing the planes (the space occupied by each object), a particular hardness is used for each one. The softest pencils permit greater contrast of value and should therefore be used in the foreground, while as the more distant planes are dealt with, and less contrast is needed, the pencils used should be harder.

Creating Atmosphere with Lines

Atmosphere is created in the drawing by the use of tonal values that produce a sensation of density. The lines should also be drawn in accordance with this principle, changing their definition depending on their distance from the observer in the different planes of the drawing.

Blending with Stumps in the Evaluation of Planes

The use of a stump is an important technique for shading as it helps to soften the lines and blend the tones together, modifying the planes that need to be merged into the whole.

Blending, however, should only be used when the drawing really calls for it, because if it is overused it creates a monotonous effect. A stump blends the tones and lines, an important aid to creating atmosphere. However, it should not be overdone, as a certain separation should be left between the planes, which should be se-

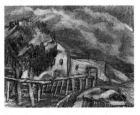

The atmosphere in this landscape has been intensified by the unity between the shadows and the contrast between the light areas.

MORE INFORMATION

• Stumps **p. 30**

parate entities in themselves with respect to the drawing as a whole.

Atmosphere and Separation from the Background

In order to create a drawing with a certain atmosphere, complicated tonal values are unnecessary; it is sufficient simply to separate the figure with respect to the background. Dürer solved this separation of the figure from the background by using white highlights as shown by these hands. The one nearest the observer is more strongly lighted, producing a slight effect of atmospheric distance between the two. They were drawn in black and white ink on blue paper.

Albrecht Dürer,
Praying Hands.

In this example you can see the two types of lines that have been used to produce the planes separated by the atmosphere.

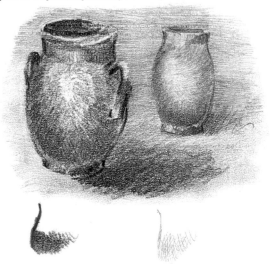

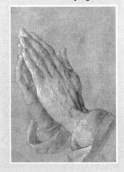

DRAWING WITH A REED-PEN

Inks play an important part among the different pictorial techniques. They can be applied to the drawing in many ways depending on the medium used. Reed-pens produce characteristic lines and forms. The tradition of reed drawing spreads as far as Eastern art and has come down to us as a delicate technique having its own characteristics.

Preparing a reed or stick for drawing is simple. After cutting the tip at an angle, just make a small cut lengthwise.

Different Lines Using a Reed-pen

A reed-pen can produce a wide variety of lines depending on the requirements of the subject. Lines drawn using the tip of the reed are soft and quite different from the hard lines produced by a metal nib. Lines drawn with a reed, however, cannot produce the same modulations as the metal nib.

Reeds offer great potential as they make use of two factors:

Reeds can produce a wide variety of effects, creating different ranges of grays depending on the amount of ink used.
Reed work can be alternated with brush work.

the pressure applied and the amount of ink used. To these two factors we can add the use of diluted ink to create texture and introduce gradation into the gray lines.

Cross-hatching and Planes

When drawing with a reed, there are different possibilities not only for drawing lines but also for the combination of planes and cross-hatching, using either a sharpened reed or one that is about to run out of ink.

A sharp tipped reed with a good amount of ink is perfect for linear work; if, on the other hand, the tip is dull and little

Contrast of vertical lines, using less ink for the lightest and more for the darkest.

A woven effect is achieved by cross-hatching.

ink is used, values similar to yet more intense than those achieved with a pencil can be obtained.

Cross-hatching is a combination of vertical and horizontal lines and can tend toward black if very closely drawn. If the cross-hatched plane is combined with others, alternating vertical and slanting lines, geometric volumes can be created whose direction is shown by the light, further darkening the areas in shadow.

Laying Out the Drawing

Before drawing with pen and ink, a careful pencil drawing should be done, indicating the areas in shadow, which will then be filled in with ink.

Soft grays alternating with lines. This was done with a dull tip and little ink.

Superimposing dark planes over a soft grayed value.

Alternating cross-hatching with the direction of the planes, in which lines change direction many times, creates geometric volumes.

Linear work using a thick, well sharpened reed and a large amount of ink.

MORE INFORMATION
- Ink: technical applications (II) **p. 74**
- Drawing with a pen **p. 84**
- Practicing with ink **p. 86**

This is the result of the techniques used.

Backlighted forms drawn using a double shading; one light and the other more dense, always drawn vertically.

Combination of cross-hatching ranging from completely black to dark gray.

Lines drawn using a fine reed.

A Simple Instrument

For reed drawing, the most suitable instrument is sharpened bamboo cane, yet good results can be obtained by beveling a small stick or even sharpening a clothespin, a practical and economical recourse.

Ink and Wash

Reed drawing, like other techniques using pen and ink, is perfectly compatible with wash. This opens up a wider range of possibilities than a simple wash, as these techniques allow the artist to work on dry and on wet.

Drawing with a reed-pen on wet paper creates diffused lines that merge into the value of the wash used.

Shading with a Reed-pen

Shading can be more subtle when using a reed than a metal nib, as the reed, being porous and almost dry, allows the artist to produce a variety of grays. The result is similar to that obtained using a pencil. The shading of the forms with respect to the light depends not only on the cross-hatching but also on how worn the tip of the reed is.

So, despite the apparent similarity between this technique and the metal nib, evaluation is more a question of values such as those produced by a lead or graphite pencil.

The shading in the dark values of a reed drawing is obtained by using very little ink.

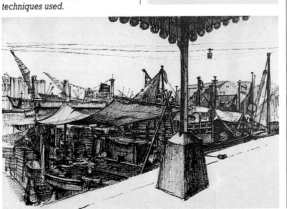

INK: TECHNICAL APPLICATIONS (I)

Ink, whether applied with a brush, a pen, or a reed, offers a wide range of effects. Brushes allow the artist to alternate between two different shapes of expression: line and wash, creating a variety of artistic possibilities, such as varying the width of the lines, rubbing with the brush, or obtaining transparency through the use of wash. Other techniques such as the fountain pen, felt pen, metallic nib or reed have their own forms of expression, which need to be understood in order to be correctly applied.

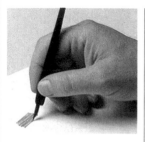

The handle held almost vertically produces an even line, while if it is slanted, it is easier to vary the thickness.

The Position of the Handle

Nibs can be used to produce both uniform lines and lines that vary in thickness. The degree of pressure applied is fundamental in modulating the line on the

paper as is the position of the handle with respect to the support. A handle held in a normal manner, that is a writing position, will produce regular lines with an even pressure throughout. Holding the handle in a more slanted way allows the nib to open when pressed against the paper, so that the line will vary in thickness.

The lines that form the different planes follow the same direction.

The Right Paper for the Ink

The choice of paper is of great importance, depending on the type of drawing the artist intends. High quality satin paper is suitable for any technique, because the lack of texture means that both nibs and fountain pens pass smoothly over it. Paper that has a certain texture or pronounced grain, on the other hand, is particularly suited to reed or brush work to take advantage of the textured effect.

Two examples of the effect of ink on paper: Nib drawing on satin paper and a brush drawing on rough paper.

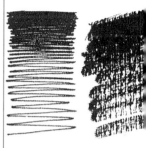

Cross-hatching, Lines, and Values

When you intend to obtain different values using a single kind of ink and no wash, the answer is to alternate the lines with the white of the paper

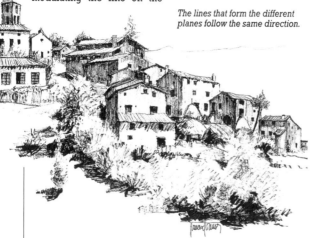

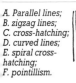

A. Parallel lines;
B. zigzag lines;
C. cross-hatching;
D. curved lines;
E. spiral cross-hatching;
F. pointillism.

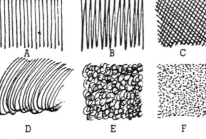

A B C

D E F

Gradations:
1. zigzag;
2. parallel lines varied in width.

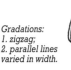

1

2

itself. Each kind of line, depending on its proximity and shape, can produce planes having different values and volumes. Drawings made with a nib usually alternate different kinds of lines to create shapes, chiaroscuro, or different planes of the objects.

Depending on the kind of line used, a plane with a particular value can be created; for example, a parallel, straight, and even series of lines for a shadowed wall; a zigzag series, depending on how close together they are, can produce a dark value or a gradation of black toward gray; cross-hatching is like a network of lines that crisscross to reproduce a textured gray effect. A simple way of creating volume is to use a series of circular lines. Another way to create shading is to use small spirals or dots. Values include a parallel cross-hatching, modulating the lines, or a tight zigzag using a reed-pen.

Cross-hatching and Gradations

Applying different kinds of lines enables us to create different planes. Even in a simple drawing a large number of different values can be introduced by just following the direction of the plane of the different objects in the subject matter.

The lines that form each of the different planes follow the same direction.

To produce a cross-hatching of parallel lines with gradated shadows, first a pencil drawing is made, accurately defining the main areas of shadow. Then fine parallel lines are drawn over the entire surface of the drawing, but without any shading. Last, the lines covering the shadowed area are made thicker. The pencil can be erased when the ink is dry.

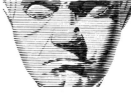

First the entire drawing was completed in pencil. Parallel lines have been drawn over the surface and lastly they have been thickened in the shadowed areas.

MORE INFORMATION

• Wash **p. 58**
• Drawing with a reed-pen **p. 70**
• Ink: technical applications (II) **p. 74**

Alternating the Nib and the Brush

Nibs produce fine, neat lines for outlining any drawing to which shading is later added to model the form.

A drawing made with a nib need not contain any shading. A single line for the form is more than enough to indicate concisely the different planes of the model. Once the entire drawing has been completed, you must wait until it dries before starting with the brush; otherwise the lines will merge with the wet ink. If the paper has a certain grain, this can be taken advantage of when creating the different grays with the brush. Using just a small amount of ink, with the brush almost dry, the mark it leaves on the paper will be gray, as the pores of the paper will be visible through the grays that model the different forms.

Drawing using a nib with the shadows drawn using an almost dry brush.

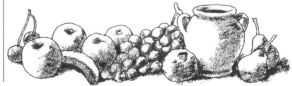

INK: TECHNICAL APPLICATIONS (II)

Ink has an endless number of possible applications. It has broad use in monochrome, with the same possibilities as color, but seen from a drawing point of view. Practicing drawing in ink is the only way the artist can become acquainted with the many techniques of the different instruments: fountain pen, nib, masking fluid, or wash.

Pointillism Using a Fountain Pen

A fountain pen can be used to produce an effect resulting from a series of regular dots, with no alteration in texture. Here, planes of grays are created by filling an area with a certain saturation of dots. Pointillism can produce almost photographic results, as the values, depending on the saturation of points, range from almost white to the deepest black. This type of drawing usually requires a highly accurate pencil study, which includes shadows and lighter values. The darkest areas are dotted first, becoming less intense as the shadow fades.

Pointillism creates almost photographic effects. The density of the dark areas depends on the depth of the shadows.

After drawing the subject, masking fluid is applied to the areas where the ink should not penetrate. When dry, the wash can be applied and the fluid removed later to produce pure whites.

Preserving White Areas: Masking Fluid

Masking fluid is the best method for protecting white areas. It can be bought in fine arts stores and is basically used to protect certain areas when applied with a brush. Its application presents no difficulties whatsoever. Once the initial drawing is complete, masking fluid is applied to the areas we wish to protect from the ink. It dries in just a few minutes and you can then paint without fear of staining the protected area. When the wash or ink is dry, the film the fluid leaves can be removed using a crepe eraser or peeled off with the fingers.

Preserving White Areas: Masking Fluid, Fountain Pen, and Wash.

When you are more familiar with handling masking fluid, it can be used to achieve different effects. For example, after completing the initial drawing, masking fluid is used to protect the areas that are to remain white. When dry, any kind of texture can be applied to the surface of the drawing, using a sponge soaked in ink. Following this step, a wash can be applied to complete the

Variety in Lines

When working in ink, it is necessary to achieve the maximum effect from the possible techniques available. The alternation of different techniques, suited to each medium, is important to avoid a monotonous, boring result..
Van Dyck (1599–1641) was a fine draftsman, and in the *Descent of the Holy Spirit onto the Apostles* he shows his great mastery of chiaroscuro using brush and ink. The tonal masses alternate with the subtle lines that define the group of figures.

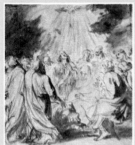

Anton Van Dyck, Descent of the Holy Spirit onto the Apostles, *drawing in sienna colored ink and brush.*

working with a nib or brush. This engraving effect is achieved on scratchboard. The drawing is a negative, that is, the card is painted entirely with black ink and then a pointed object is used to scratch lines in the black surface. Then cross-hatching, planes, and variations in value can be added the same as in any other technique using ink.

Block Style

This drawing technique represents just black masses,

A drawing on scratchboard. This is a negative drawing technique in which the whites are scratched into the black surface.

eliminating any intermediate tones or values.
Drawing in this style requires first a pencil drawing that distinguishes accurately between the two areas of contrast, without losing sight of the shapes themselves. A pen is used for the fine lines and a brush for the larger areas.

shading of the drawing. Again, when this is dry, the fluid can then be removed.

Clean Lines

Another of the possibilities when drawing with ink is a

The process of preserving white areas is carried out after the drawing is done. The latter can then be textured using ink and a sponge, without pressing too hard. Last, the masking fluid is removed after painting the wash.

clean line, that is, one without any kind of shading, using a constant and even line. This can be done with nibs, fountain pens, or brushes.

Imitation Xylography

Although this is not a positive kind of drawing, the technique used is similar to

A linear style drawing.

> **MORE INFORMATION**
> • Wash **p. 58**
> • Drawing with a reed-pen **p. 70**

Before starting this drawing a sketch was done to carefully mark off the light areas. A pen has been used for the finer lines and a brush for the larger areas.

MODELING A FIGURE IN CONTÉ

The nude is one of the favorite themes of most artists. A model can be used for studying different shapes of illumination, for composition, or, from the anatomical point of view, of proportion and analysis of the foreshortening of figures.

Conté crayon is a drawing medium with a wide range of tones. It is easy to blend and so the only limitation to the process of evaluation is the artist's own expressive capacity.

Sanguine Conté is a warm color and, being opaque, can be applied to colored paper, adding to the wealth of tones.

Blocking In the Figure

Blocking in the figure is carried out using a simple, linear construction, making no attempt to introduce shading at this stage. The charcoal lines are drawn holding the stick flat between the index finger, ring finger, and thumb. In this position the lines produced are firm and resolute. This also limits the movement of the wrist, which actually simplifies the drawing, to produce broad sweeps using the movement of the entire arm.

The construction of the figure is based on the angle or tilt of each of the main joints of the body, which in turn depends on the spinal column. The two main axes are the hips and the shoulders. If a simple scheme such as this is used, it will make the drawing of the figure on the paper much easier.

A Study in Light

A nude is an ideal subject for studying in depth the modeling of form and lighting. So it is always advisable to make sketches both of the pose and the lighting, to study the way in which the figure should be modeled and the correct technique for drawing with Conté.

There are many kinds of poses, though it is best to concentrate on a particular one to decide the main object of study: light, proportion, or movement. Constant practice in drawing will always reveal new possibilities that help to understand better the construction and the modeling of a figure through an analysis of the drawing.

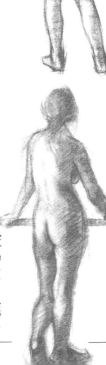

Conté crayon is excellent for quick sketches that can then be used for analyzing the elements within the drawing: the light, chiaroscuro, pose, or anatomy.

Basic materials for sketches: charcoal, sepia, sanguine Conté crayon, eraser, and paper.

Ink: Technical Applications (II)
Modeling a Figure in Conté
A Portrait in Conté and Charcoal

77

Modeling and Blending

Modeling shapes follows two basic drawing methods. One is gradating the values using the Conté; the other is blending, in which the Conté is gently rubbed with the finger or with a stump to produce a soft tone.

When rubbed in with the finger, the Conté penetrates the paper, creating a different type of shadow from that of the stick and, at the same time, losing some of its spontaneity. This kind of work is necessary, however, to study the way the light falls on the body.

Use of Value for Modeling

After studying and blocking in the pose, we can start to work on the shading of the figure. This is done by darkening the entire sha-dowed area without applying too much pressure and then gently rubbing to obtain an even, overall tone. The next step is to darken the value of these areas in which the muscles are indicated by the shadows.

The first shading is done lightly to avoid any unneces-sary correcting of the drawing. If the paper has a medium or rough grain, this texture will be apparent in the result.

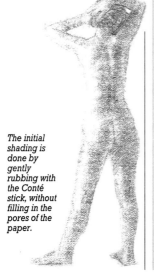

The initial shading is done by gently rubbing with the Conté stick, without filling in the pores of the paper.

Mastery in Drawing: Rembrandt

Rembrandt approached his drawing in a direct, almost definitive manner, with hardly any preliminary steps. Reaching such a mastery of technique is one of the most difficult goals for the artist. Dedication and a study of drawing techniques will enable you to capture the model with increasing ability.

Rembrandt, Cleopatra. Conté drawing.

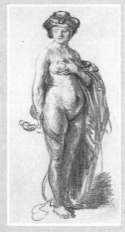

Shading with Conté includes blending. Here you can see blending done with the finger and the effect before and after.

From the Sketch to the Final Drawing

The process that continues from the sketch through to the final drawing is basically one of careful shading. The small accents of a darker tone help to define the volumes, which, in the first process of shading, were left somewhat flat.

From the blending through to the finished drawing, the work with the fingers alter-nates with the Conté, either to soften the lines or to define them in contrast to the back-ground.

MORE INFORMATION

• Anatomy **p. 16**
• Human proportions **p. 18**
• The sketch **p. 42**

TECHNIQUE AND PRACTICE

A PORTRAIT IN CONTÉ AND CHARCOAL

The ability to combine drawing media is of great interest when planning a new work.
Conté and charcoal are two media that can be used simultaneously,
merging their tonalities in a natural way.
Portraits are one of the great challenges for the artist, as capturing the resemblance by
means of line and value is no simple matter; it requires practice and a sound
knowledge of techniques.

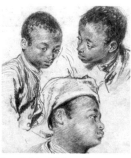

Jean Antoine Watteau, *Three Studies of the Head of a Young Negro. The proportion of the features is identical in each of these three studies of the same person.*

The Structure of the Face and the Different Features

A face is a structure within which the different features are situated. There exists a certain proportion between the size of the feature and its position with respect to the others.

Each person has a series of features that distinguish him or her. These features are the curve of the plane of the face, the geometry of the forms, and the distance between the features. Essential factors to bear in mind when drawing a portrait are the distance between the eyes, which always differs, the relationship between this measurement and the length of the nose, and the distance from nose to mouth.

Initial Forms in Modeling

Conté and charcoal are two dry media that are fully compatible. They can be blended or mixed without any difficulty as both charcoal and Conté use pure pigments: vegetable in the case of charcoal and mineral in Conté.

As in all drawings, the choice of paper is basic to control the value changes, as heavy rough paper, for example, has a texture that makes it difficult to produce soft middle values. If medium texture paper is used, however, this will simplify both erasing and blending.

If you draw from a photograph, as in this case, it is

The charcoal sketch. The proportions of the image were used as an aid.

easier to calculate the proportions, as a two-dimensional plane is available as a reference. Holding the charcoal flat, the face is blocked in: the upper third is occupied by the cap and the background, the second third by the face, and the lower third by the beard.

Features and Resemblance

Once the drawing is blocked in, the features are situated in the correct proportion, without any shading despite the model presenting sharp contrasts. The features should be carefully drawn, paying special attention to the lines of the eyes, the nose, and the space that separates the individual elements of the model. One of the great advantages of charcoal over other drawing media is the ease with which you can make corrections. A soft grayish mark will be left if you simply rub the area with a cloth. If you wish to remove it completely, you must use a kneaded eraser.

Once the model is blocked in, the different areas can be filled in, first with the charcoal held flat to gently cover the entire background. Then using

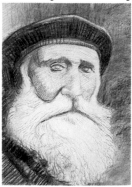

Holding the charcoal flat, the entire background has been laid out. The cap and the clothes are drawn using lines that follow the direction of the plane formed by them.

Modeling a Figure in Conté
A Portrait in Conté and Charcoal
Portrait Technique
79

the tip of the charcoal, the area of the cap and clothes are elaborated, with the lines following the direction of the plane. Lastly, the planes of the face are formed with soft lines in Conté crayon.

Alternating the Two Techniques

Once the main outlines of the volumes of the face have been established, the face is shaded in using Conté and charcoal, alternating the blending of both media and reinforcing the lines.

This initial shading of the face is then gently blended to lend unity to the shadows and lines. This involves the two basic drawing techniques: blended areas and lines.

The natural sanguine Conté can be used for the initial shading of flesh tones and the warm reflection on darker areas of the cap and the beard. Over this modeling of the face, accents of sepia Conté are

The sepia Conté is perfect for a gentle transition between the contrasts, blending with the lines of sanguine Conté to outline the features and augment the shading of the darker areas.

The face and the features are modeled using a broad stroke that follows the direction of the volume of the forms.

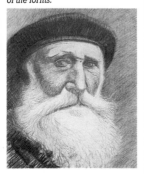

MORE INFORMATION

- Drawing facial expressions **p. 20**
- Conté with white highlights **p. 52**
- Portrait technique **p. 80**

Drypoint

Drypoint allows you to create great variation in values by means of cross-hatching. To make a drypoint all you need is a polished copperplate and any pointed tool. After drawing the subject on the plate with a grease pencil, the drawing is traced over with the needle, scratching the surface. The drawing is similar to that obtained with a pen, that is, lines and cross-hatchings for the dark areas. The finished drawing is inked with printing ink and tarlatan (a kind of gauze). The plate is cleaned with newspaper, leaving the ink in the lines. The paper is wet, placed on the plate, and then passed through the press.

Rembrandt, Self-portrait with Terrified Expression. Drypoint engraving.

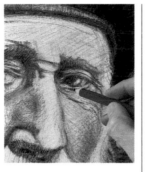

added, alternating the lines with the blending of tones.

Finishing the Portrait

Drawing in Conté provides a very wide tonal range, with the possibility of opening up luminous whites in areas that are too dark. Continuing this way, with value changes indicated, the drawing is finished, alternating the previous techniques with the eraser.

The lines of the face have been lightly blended to introduce new lines (on the cheekbone) that are softer than the previous ones, alternating sepia and sanguine Conté.

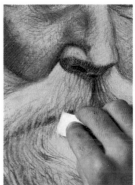

The eraser is used to open up light areas where the drawing appears too dark.

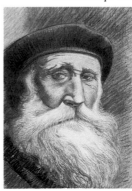

More detail is added to the shading as the face comes nearer to completion.

PORTRAIT TECHNIQUE

The portrait is one subject that few artists have been able to resist, even using just pencil and paper. To capture the face and the personality of the model requires a thorough knowledge of drawing techniques and how to represent the features in proportion to each other.
In any case, we cannot say there is only one method of portrait painting. Some are decidedly academic in style while others are more free and spontaneous.

Using the pencil as a measure you can roughly block in the proportions on the paper.

A Study of Form

Portraits use certain measurements in order to block in correct proportions. The face, the features, and the form of the head or trunk can be interpreted as geometric shapes, to aid the placement of the figure on the paper.

The essential forms are always the same: the oval, cone, cylinder, and cube. The features require situating and defining in accordance with these shapes, depending on the artist's skill and capacity for observation.

A Study in Charcoal

Charcoal is excellent for establishing the forms of the face and can also be corrected, whatever stage of drawing the artist has reached. The construction of the head and face can therefore be modified as the artist wishes. The study of the face and the resemblance may be more accurate in some areas than others, although it represents no problem as it can be erased by simply rubbing out the mistake with a cloth and then redrawing the line of colored area.

Studies should always be made before drawing a portrait, in order to interpret the model more fully. These studies should aim to capture the main proportions and features, without attempting to produce a likeness for the moment. This can be done later using the studies and notes as a guide.

These studies should cover the most important aspects such as the proportions and the pose.

Shading with charcoal indicates the planes of light and shadow.

Shading and Volume

The construction of a portrait requires time and thought with regard to the forms of the model. It is through a constant process of changes of line and value that the form and the likeness are achieved. The process of shading runs parallel to the construction, distributing the light and dark values. In the beginning we divided this into two main areas of light and now we must refine the light values as accurately as possible. There are two basic tools for achieving this: the hand for blending and the kneaded eraser for opening up white areas to create the features, such as the shape of the nose or the cheekbones. The eraser is used to draw in

Over the previous shapes the process of shading starts, using the fingers to blend and model the dark areas and the eraser to open up white areas and highlights.

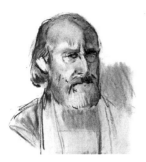

The shadows and the light areas define the shapes, alternating shading and lines for the features.

the same way as charcoal, opening up lines or simply shaping the form of the forehead.

Resemblance

Once the main shapes of the face have been carefully blocked in and the features need no further correction, we can start to work on the resemblance to the model.

This is obtained through a detailed series of lines on the face, using charcoal and the eraser, opening up white areas where the light produces highlights. The values still require refining, increasing the middle and dark values in the areas that require modeling and that will stand out as a result of the contrast. In this case, the back part of the head has been darkened and lines defining the eyes and the beard have been added. Lastly, the darkest areas have been reinforced to emphasize the highlights and medium values.

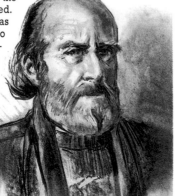

When the likeness becomes clear, it is the result of studying the light and such details as the beard or the highlights on the forehead.

Self-portraits enable you to practice drawing and studying the proportions of the face in many different ways.

MORE INFORMATION
• Drawing facial expressions **p. 20**
• The study of the human head **p. 22**
• A portrait in Conté and charcoal **p. 78**

The contrast between the different areas of light is heightened and the lines that produce the likeness are reinforced.

The Self-portrait as an Exercise

One of the most practical ways to acquaint yourself with the technique of drawing portraits is the self-portrait. This is an exercise that all artists have used and, if practiced regularly, will rapidly increase your skills and knowledge of this technique. Self-portraits can be practiced from many different viewpoints, using a model who will be patient and unaffected by the results...the artist himself or herself.

The Portrait and Geometry

As every artist down the ages has repeated, all forms can be reduced to pure geometric shapes. The use of geometry when representing faces developed above all with Cézanne, the main forerunner of cubism. His portraits are full of planes of light and shadow, geometric planes reinforced with areas of pure color.

Paul Cézanne, Portrait of Joaquim Gasquet.

CHARCOAL TECHNIQUES

Charcoal can produce a wide range of values, from the palest grays to the deepest blacks. Made from burnt spindle tree wood, its dust is highly unstable. This is a great advantage as it is easily manipulated and can produce tonal values by simply rubbing with the fingers, a cloth, or a stump. Charcoal techniques include most of the other drawing techniques.

Charcoal and Fixative

Charcoal was undoubtedly the first medium that was used in drawing, and throughout history it has adapted to the different styles of the artists who have used it.

Fixative was not discovered until the 16th century, yet this simple development meant that charcoal ceased to be a short-lived drawing medium and became a technique worthy of masters such as Tintoretto or Titian. Charcoal became one of the most noble of techniques.

Different media that are compatible with charcoal. 1. stump; 2. sanguine Conté crayon; 3. sepia Conté crayon; 4. soft charcoal; 5. charcoal pencil; 6. sanguine Conté pencil; 7. sepia Conté pencil.

Charcoal is still the main medium used in fine arts schools, although other, compatible media are also used, such as Conté and charcoal pencils.

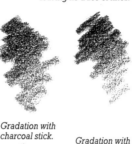
Charcoal dust.

Charcoal Dust

Charcoal dust is basically used for creating gradations and blending, using a stick that is covered with this dust and then used as a pencil. One of the advantages of charcoal dust is that when removed it leaves no trace, as it does not affect the paper in any way.

Another possible application is one in which a stump is moistened in linseed oils, in which case it becomes a technique more similar to ink.

Gradation with charcoal dust leaving no trace of lines.

Gradation with charcoal stick.

Gradation with a stump.

Basic Techniques

Charcoal is one of the most complete drawing media, as its lack of stability (when fixative is not used) is also one of the advantages that other media cannot offer. For example, it can easily be erased with the fingers, or half erased to produce medium values; if it is blown on, the darkened areas lose contrast. Even deep black can be erased with the fingers, although if the pigment has already penetrated the paper, some mark will be left behind. This can be removed with an eraser.

Another advantage is its great usefulness for shading, as the values can be intensified, blended, and graded.

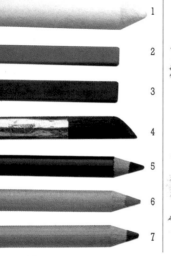

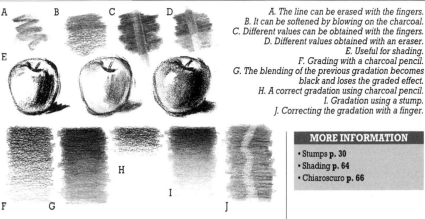

A. The line can be erased with the fingers.
B. It can be softened by blowing on the charcoal.
C. Different values can be obtained with the fingers.
D. Different values obtained with an eraser.
E. Useful for shading.
F. Grading with a charcoal pencil.
G. The blending of the previous gradation becomes black and loses the graded effect.
H. A correct gradation using charcoal pencil.
I. Gradation using a stump.
J. Correcting the gradation with a finger.

MORE INFORMATION
- Stumps **p. 30**
- Shading **p. 64**
- Chiaroscuro **p. 66**

Characteristics and Possibilities

Charcoal can be used on its own or in combination with other drawing media, merging with them through gradations or mixed lines. When colored paper is used, the form is brought out by the contrast of the background and the sepia Conté or white chalk used to create highlights and light areas of great impact.

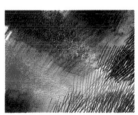

Possible charcoal techniques used in combination with sepia and sanguine Conté. Here we can see how the different techniques are applied: strokes, blends, gradations....

Different Lines with Charcoal

We can differentiate between three basic types of line that can be obtained with charcoal, irrespective of the shading for which it can also be used.

Charcoal cannot be sharpened to a point as it crumbles

easily. Charcoal lines can be fine and intense if the edge of the stick is used. If the flat tip is used the line will obviously be thicker. Another possibility is working with the stick held flat against the paper, in which case a particular area can readily be shaded in.

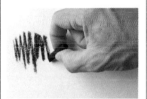

Line with the tip.

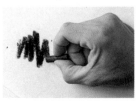

Line with the flat tip.

Line with the stick held flat.

The Forerunner of Charcoal

Black stone is one of the drawing media that were used before charcoal and lead. It is a clay-like form of slate that comes in sticks. It was used in Italy, from the 15th century on, for drawing the human figure and for preliminary sketches. In the 18th century black stone began to be used in landscape drawing, until the following century when it was replaced by charcoal and pencil for all types of subject matter.

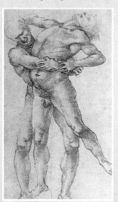

Luca Signorelli, Two Nude Men Fighting, *black stone.*

TECHNIQUE AND PRACTICE

DRAWING WITH A PEN

Pens, like reed-pens, have a long tradition in drawing, with their own techniques of alternating lines and modeling. Today, pen drawing has been replaced by drawing with nibs, of which there exist a wide variety.
Nib work can produce results of great simplicity or complexity, from almost bare lines to hyperrealist representation.

Metal Nibs and Other Compatible Instruments

Drawing with pen and ink can produce elaborate lines and variations of value. This can be done in two ways: by using lines, drawing them close together to intensify the shading, or by starting with shading carried out in wash, applying gray inks with the same line technique used in the gray of the cross-hatching, although without the use of wash.

Nib drawing is compatible with all other ink techniques, alternating lines and washes produced with other drawing instruments such as the reed-pen, brush, or fountain pen.

Ink comes in various qualities. What all inks have in common is that if they are diluted, distilled water should

The ink used for nibs can be India ink or fountain pen ink.

always be used, as it contains neither lime nor chlorine.

Colored inks also used in nib drawing.

MORE INFORMATION

• Drawing with a reed-pen **p. 70**
• Ink: technical applications (I) **p. 72**
• Ink: technical applications (II) **p. 74**

Types of Nibs and their Maintenance

The different lines a nib produces depends on its hardness, although three sizes are usually sufficient. The smallest has a fine line, similar to a fountain pen; the medium size allows you to vary the thickness of the line, while the largest can apply more ink and is better suited to thick, even lines.

Taking good care of nibs is essential, as they are very delicate and easily damaged. If the tip of the nib is damaged, it must be thrown away. It is advisable to wash them after each use to avoid any ink becoming encrusted. They should be carefully dried and stored.

Lines

A nib allows you to draw a continuous, even line and is therefore essential for drawing in ink. The lines drawn with a nib can be broken or continuous, and more ink taken up when it has run out.

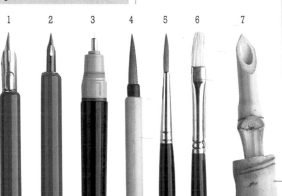

Different drawing instruments that are compatible with nib work:
1. Osmiroid fountain pen.
2. Perry metallic nib and handle.
3. Fountain pen.
4. Chinese deer hair brush.
5. Sable hair brush.
6. Hog bristle brush.
7. Bamboo reed-pen.

Chiaroscuro Using a Nib

Rembrandt (1606–1669) was a virtuoso draftsman at representing light. Any work by him constitutes an example to be followed. He was also perfectly acquainted with the use of the nib, as you can appreciate from this drawing. The cross-hatching of the shadows is perfectly uniform and the gradation of the values is excellent.

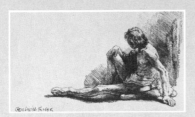

Rembrandt, Boy Sitting. Pen drawing.

Working with a reed-pen is similar to the technique used for nibs, allowing the artist to create different grays.

A drawing using a hard nib can be replaced with a fountain pen, which come in a wide variety of thicknesses.

The sharpness of the lines also depends upon the kind of paper you are using.

Cross-hatching with a Nib

Cross-hatching is the result of crisscrossing a series of lines to fill a particular area, so that the impression perceived is one of an even, textured surface.

Nibs allow the artist to create a large number of different cross-hatchings, from the most subtle shading of light values to deep blacks.

A drawing with a nib, showing the different cross-hatching used.

One of the problems that can arise when drawing with a nib is that if the right quality paper is not used, the tip sometimes "digs" into the paper and picks up fibers that absorb ink and can mar the drawing. To prevent this from

A completely lineal drawing with a hard nib. Shadows are created using a series of lines that join together to increase the intensity of the dark values.

happening, use the right quality paper and clean the nib before it occurs.

Nibs Used in Combination with Other Ink Techniques

You can alternate the use of the nib with other ink instruments. Experiment with the different possibilities before carrying out the final drawing to avoid any unwanted surprises.

When working with a nib on a wet surface, the line spreads. If used carefully this can produce some interesting effects. You can also combine lines drawn with a reed-pen with the fine lines of the nib, alternating them as shown in the illustration.

Spiral lines for the treetop.

C-shaped lines.

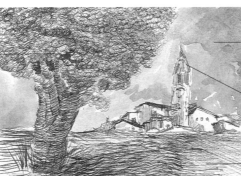

Wash, using a brush.

Zigzag lines for the houses in the background.

Cross-hatching to develop the value of the ground.

PRACTICING WITH INK

The basis of drawing is the line. From this the volumes are created by modeling the
forms by applying the medium to the paper and drawing
the forms with clear, clean lines.
The strokes define the forms, indicating how the light is reflected on them
and outlining their volume against the background. Wash, on the other hand,
is used to situate the different planes of the model, creating
the shading inherent in drawing.

*A few simple masses can define
the light and shadows.*

Blocking In Drawings with Sepia Ink

A great many variations of value are possible with sepia ink, covering such a wide range of shading that any plane in which atmosphere is required can be drawn.

Before developing any kind of drawing it is first necessary to make a sketch. This may consist simply of colored washes that define the separate forms between the lights and shadows. It may also consist of several masses of different values with interconnecting lines.

Once the overall shapes of the subject have been defined, they are blocked in using a detailed drawing that should not, for the moment, contain any kind of shading.

The Initial Wash

The initial wash in sepia ink always moves from a light tone to a darker one, as the white that lightens the value is the white of the paper itself. Over the preliminary sketch, a light wash is applied and new

*Wash is applied over the
drawing so that the values
change from light to dark.*

values added to the areas to be darkened. This combination of tones can be done in two ways: on a dry background, alternating the different dark planes over the lighter ones; or on a wet background, before the wash has dried, adding tones that are graded toward the damp areas.

*The effect of wash. The darker
areas alternate with the
lighter ones.*

Types of Stroke

The stroke or line is the basic technique in drawing, which is used to outline forms and produce the shadings for them. You should wait for the wash to be completely dry before using the pen; otherwise the ink will run and spread over the wet paper. Different kinds of lines are possible with a pen, depending on the plane on which you are working. Outlines, for example, should always be drawn with a firm hand or the drawing will appear hesitant, and these lines are always thicker than those used for cross-hatching and shading.

*A soft stroke to underline
the texture of the shapes.*

*A firm, thick line to enclose the
forms.*

Shading with Lines

The surface now has a given basic value and the lines will reinforce the forms and volumes. The pen and wash are now combined to produce a series of effects that increase the shading done with a cross-hatched texture.

The areas you wish to keep light and sharp can include a gentle parallel series of lines covering the entire tonal background, as a reinforcement of the wash. Sepia ink, on the other hand, produces an effect of contrast if the pen work has been applied onto a damp, not wet, surface. When applied, the ink spreads and blends in, creating a contrast with the background. This is one way to model the forms in the foreground using shading.

A Delicate Use of Ink

This form of ink can produce glazes and contrast of great tonal delicacy, using a technique that combines superimposing tones from light to dark. In this way the artist can first establish the drawing of the softer gradations and lastly the darker ones. That is how this minutely detailed landscape was drawn.

Thomas Gainsborough. Gray ink with white highlights.

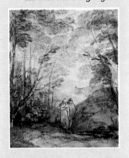

MORE INFORMATION
- Wash p. 58
- Ink: technical applications (I) p. 72
- Ink: technical applications (II) p. 74

Using the pen on the dry surface you can draw a delicate, even cross-hatching.

A Contrasting Finish

Over the initial process of shading using a pen, the forms are then defined and the contrast is the result of the exchange of tones produced with the wash and the pen strokes.

The difference in value between the foreground and the more distant planes should be emphasized, as well as the value variations that allow the artist to increase the contrast of the initial shading done with the wash.

It is important to observe the difference between the background planes and the foreground in which the work is far more detailed.

By alternating the pen and the brush, the shapes acquire volume thanks to the effect of simultaneous contrast.

By alternating the effect of the strokes against the slightly damp background, the foreground can be darkened.

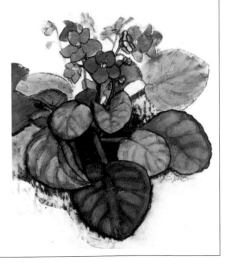

CRAYONS

The wax crayon is one of the plastic media with the most pictorial potential. Applied to the technique of drawing in the form of planes, it can create dense and opaque surfaces or light, transparent ones. It can also be used to reserve tones or as a pure drawing medium.

Negative Drawing

Different shapes can be obtained using wax crayons or paraffin on medium texture Canson paper. These lines can be lost if white paper is used and a fine outline has not been drawn first using a hard pencil. Any H grade pencil is suitable for this.

The wax crayon is applied as thick as the artist wishes, from a thick layer to produce a glaze or a fine line of crayon like a pencil.

When the initial form of the drawing has been completed in crayon, a wash is applied to the surface. This wash cannot penetrate the area, and will produce an effect similar to a photographic negative.

A Color Negative

Negative drawing has a great number of possibilities, which can be combined in a negative drawing and in a positive one.

A negative drawing in color produces a result that combines drawing and a pictorial approach, yet it cannot be described as a painting as this kind of work always reduces the colors to flatness.

Although this process is similar to that of monochrome work, several considerations should be borne in mind. As a wax crayon is neither white nor transparent, it does not blend with the color of the paper but shapes an opaque

After drawing the colored planes with the crayon, the wash allows you to resolve the drawing in those areas where the crayon has not been applied.

plane, and this should be taken into account when approaching the drawing.

Wax Crayons and Turpentine

Crayon dissolves perfectly in turpentine and can then be used to produce two types of line: dry lines, using solid crayons; and lines that are then drawn over using a brush dipped in solvent.

In this way you can produce values with crayons as if they were wash and solid crayon can be applied later to define, outline, or finish the drawing.

The degree of transparency depends upon the amount of solvent applied, and diluted transparencies similar to those of watercolor can be obtained. These can later be superimposed when the underlying layer has dried completely.

To obtain a negative image, you only need draw with a wax crayon and then apply a wash.

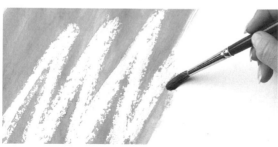

Washes in Negative Drawing

Negative images are one of the most striking effects you can obtain using wax crayons. They can also be combined with any other technique, as you can see from this still life. The masterful drawing has been combined with other techniques using layers of color, and lastly a wash was applied over all the areas that appear black.

Still life done with crayon on paper by Miguel Ferrón.

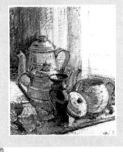

The diluted crayon is dissolved by passing a brush dipped in turpentine over the crayon drawing, creating highly diluted glaze effects.

Sgraffito

Among the different techniques possible when drawing with crayons is sgraffito, a highly effective method. It consists of incising a surface

To draw in sgraffito, flat, superimposed layers of wax crayon are applied and then any pointed object is used to scratch the surface.

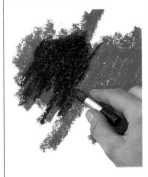

that has previously been covered with a wax crayon of a particular color. Crayon is opaque and fairly soft, making this a simple job.

Sgraffito can be done on any surface covered with crayon, although the most striking effects are obtained when two or more layers of color are superimposed. Any pointed instrument can be used to scratch the surface, revealing the underlying colors. Special arrow-tipped instruments are available for sgraffito work, but experiment with other objects to obtain different effects. You can use a fork, for example, a ruler, a pin...any object that will remove the crayon.

Melted Crayons

Wax crayons have a very low melting point, allowing the artist to use impastos and strokes similar to those of a well loaded brush. Melted crayon is very easy to handle and penetrates deep into the grain of the paper.

Melted crayon produces highly pictorial effects. It provides flowing lines and texture and is stable, so it can be used on any surface.

Crayon melts easily. Just hold it close to a source of heat for it to soften. When it cools, it retains the same texture as when it was applied.

MORE INFORMATION
• Oil crayons and oil pastels **p. 36**

THE NUDE

Drawings of nudes are among the most beautiful artistic expressions possible. The study of the proportions of the human body and the development of its forms through its depiction on paper require a depth of technique and sensitivity that can only be acquired through practice. Drawing the nude involves every drawing technique, from a careful first sketch to the correct use of shading of different values to bring out the volume through the light and mastery of proportion.

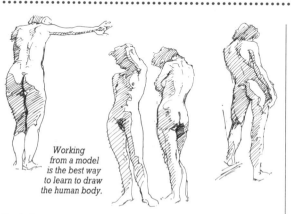

Working from a model is the best way to learn to draw the human body.

The modeling of the forms continues with the opening up of white areas with the eraser.

The points of maximum contrast are reinforced using a dark Conté pencil.

Studying Poses

A study of poses is one of the most attractive subjects for a draftsperson and for most artists in general.

Any drawing technique can be used for nudes, as the most important aspect is to understand the proportion and the relationship between the different parts of the body.

To fully understand the human body and be able to represent it accurately, practice is the best method. Modeling sessions are available at most art schools. Some are free of charge while others charge a modest amount.

Volume and Light

To create volume and light, a preliminary drawing can be used to compare the differences in changes of value in the lighted areas.

In this case we are going to use a drawing done in sanguine Conté, to intensify the values in the darker areas, such as the hair and the shadows. This new set of lines must follow the shapes of the

Increasing contrast with charcoal over sanguine Conté.

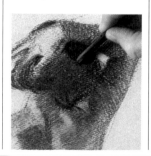

model's anatomy. The lighting is suggested by the shadows, which contrast with the lighter areas.

The highlights on the skin are reinforced by opening up white areas with an eraser, modeling the shapes and maintaining the anatomical areas in shadow. Lastly, maximum contrast is achieved using a dark Conté pencil, gently shading the shadow and following the planes of the anatomy.

MORE INFORMATION

• Anatomy **p. 16**
• Human proportions **p. 18**
• Modeling a figure in Conté **p. 76**

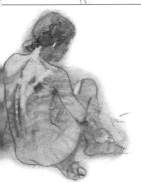

To represent this foreshortening, a good knowledge of anatomy is essential, as well as the effect that the light has on the body.

Foreshortening

Foreshortening is a system of representation that creates a three-dimensional view of the picture. The use of foreshortening produces a realistic depiction of complex positions, such as a projecting elbow or a seated figure with one knee raised.

A long mathematical process can be used to calculate the shortening of an arm for a given foreshortening, but the ideal way for all artists is simply practice. Only after you have drawn a pose from differ-

ent viewpoints can you fully understand how to interpret it.

Proportion and Pose

Proportion is one of the main factors when drawing the human figure. This involves maintaining a series of constant measurements between the different elements that go to make up the human body. This is learned through successive drawings, yet there does exist a medium that allows you to correct as you work: charcoal. A good exercise is to construct a nude pose, male or female, and develop this composition with charcoal on a large piece of paper. Holding the charcoal flat, the shapes are constructed using a piece of cloth and your fingers. Charcoal allows you to continuously correct your work constantly as you progress and develop the drawing.

Staining a large piece of paper and then shading the entire surface.

Repeatedly drawing a model from life is the most effective way of learning how to represent foreshortening. These quick sketches were made in a single session by simply changing the viewpoint with respect to the model.

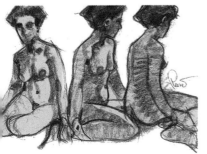

Nude Studies

Drawing models is one of the basic exercises for all artists. So, even if you cannot attend regularly, go to an art school where models are available, whenever you can.

All cities or towns generally have art centers where drawing from a model is possible. Remember that there you will learn not only from your own work but also from that of your companions.

A piece of cloth is used to open up white areas by rubbing off the charcoal.

Alternating the use of the cloth, a kneaded eraser. and charcoal. the artist seeks to construct the proportion and the light on the models as accurately as possible.

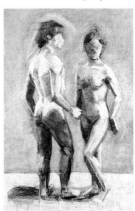

PLANNING A COMPOSITION

Drawing is the perfect technique for studying different kinds of compositions as it offers a perfect guideline right from the start of the drawing.
Planning a composition is rather like building the foundation of a building: It determines whether the structure is going to collapse or be sound.
Remember to bear these studies in mind when approaching a drawing.

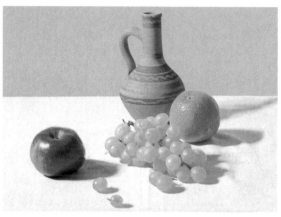

The subject matter is laid out within a given area, balancing the composition.

Planning and Blocking In a Composition

Planning a composition should not be confused with blocking it in. A single glance at an object is far from sufficient to fully understand it. A child will draw a house as a square with a triangle on top, even when the house has no sloping roof.

This is merely the result of subjective memory. When representing an object, im-

Study the subject while holding the pencil in front of it and moving your thumb until you have the right measurement.

This measurement is then compared with the other areas of the model. In this example, the height between the upper part of the vase and the lower part of the bunch of grapes is the same as the width between the apple and the orange.

agination should be avoided and you should keep strictly to the observation of reality, despite the great effort this involves. As an aid, artists use a series of schemes to prepare the model on the paper. Another, much more objective method is that of blocking in the composition, a simple process that reduces the subject matter to simple geometric shapes.

Dividing the Space

Once the composition has been analyzed, it must be transferred to the paper. An easy and practical way is to calculate the proportions. Dividing up the space when blocking in a drawing can include a hint of imagination, yet the proportions themselves must be strictly adhered to.

To estimate the proportions of the model, take any distance within the subject matter as a reference and then compare this distance with the other lines that make up the object. If you have a rectangular vase, for example, you could take the base of the vase as the reference point and then compare this distance with the height.

Estimating the proportions consists of comparing the distance between objects and noting that the same dimensions are present in different areas of the model.

Blocking In a Composition

Blocking in a composition is done by marking off a certain part of the subject on the drawing, with regard to the surrounding space. The center of interest of the picture can be chosen at will to produce the most interesting effect. Remember that the space surrounding the model is as important as the subject matter itself.

Geometric Forms in Composition

The simplest and most practical subjects for a composition are those that are

MORE INFORMATION
· Composition and sketching **p. 38**
· Blocking in, structure, and sketching **p. 40**

least difficult to represent, which can be easily drawn by reducing them to geometric forms. In this way it is easy to position the different elements within the picture and establish the different proportions between the objects that constitute the subject.

Every element in nature can be reduced to a simple form that can be fully developed at a later stage.

Balancing a Composition

Balance is achieved in a drawing by the distribution of the different elements. This applies not only to the elements themselves as objects within the composition, but also the shadows and variations of value that require balancing with the use of white.

The balance between the masses of shadow and of light create a sense of visual weight. A series of imaginary lines can be used to guide you in distributing the masses with a given drawing. The composition, starting with the masses of dark values, is balanced by the accents of light situated in such a way that they create an overall feeling of harmony in the composition.

In compositional layouts, the use of geometric shapes helps to understand the forms and estimate correct proportions.

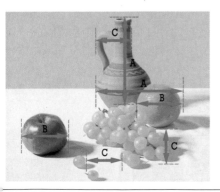

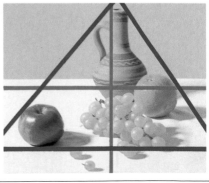

DRAWING IN CONTEMPORARY ART

Drawing has survived both the passage of time and artistic styles.
Artists of every era have used drawing as a basis for their various styles. In contemporary
art, drawing is still used as a path toward other shapes of art and as a work of art itself.

Free Pencil Work

Drawing can be free and intuitive. Alternating line and mass offers a wide range of possibilities of technique and expression, as the drawing may be completely flat or graphic.

The lines can be balanced with shapes and shapes and the alternating use of wash, cross-hatching, sweeping strokes, etc....

Expressionism

In contemporary drawing techniques, a certain expressionist influence can still be found. Color may be applied to a drawing, losing the characteristics of a drawing. In this case, the blended tones, colors, and shapes alternate with the lines, producing more concrete forms. Although it borders on the abstract, this kind of drawing using line and masses of color makes the lighter shapes stand out.

Laying in the darker masses helps to balance and emphasize the accents of light.

Drawing can alternate with color used in a pictorial manner, stressing areas of very light value that tend to stand out.

This kind of drawing can be alternated with wash or with any other drawing techniques.

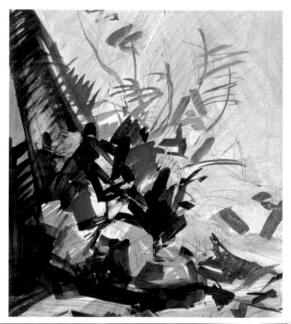

Pictorial Media for Drawing

The pictorial media most commonly used for drawing are those that allow the artist to create texture and control forms, such as oils and acrylics. It is not necessary to define the forms fully, yet the artist should be aware of them as he or she needs to incorporate the traditional concepts of balance and composition.

Abstraction often makes use of drawing to create volume.

Any pictorial medium is suitable for drawing, such as brushes or any instrument that can produce a line.

Computer Assisted Drawing

Computers provide an unlimited range of possibilities. Although it is true that powerful systems are needed for image processing, using complex shading and textures designed by the artist himself or herself, the results are often of a surprising standard. Computer assisted drawing requires the same qualities of the artist as does the traditional use of charcoal. The paper, the medium, and the technique are different, yet a computer can produce results as worthy as those of a simple piece of paper and a number 2B pencil.

Drawing made with the Photomagic program by Ramón de Jesús.

Other Drawing Media

The techniques used in contemporary drawing range from the purely traditional to the use of photocopiers. In this way, an image can be reduced, enlarged, or deformed as the artist wishes, and the result can then be modified later.

In any case, any drawing instrument, whether it is classical or modern, can give rise to innovative technical combinations.

Manipulating a drawing using a reduction or enlargement obtained with a photocopier.

Original title of the book in Spanish: *Dibujo*
© Copyright Parramón Ediciones, S.A. 1996—World Rights.
Published by Parramón Ediciones, S.A., Barcelona, Spain.
Author: Parramon's Editorial Team
Illustrators: Parramon's Editorial Team

Copyright of the English edition © 1997 by Barron's Educational Series, Inc.

All inquiries should be addressed to:
Barron's Educational Series, Inc.
250 Wireless Boulevard
Hauppauge, New York 11788

International Standard Book No. 0-7641-5007-3

Library of Congress Catalog Card No. 96-86671

Printed in Spain
987654321

NOTE: The titles that appear at the top of the odd–numbered pages correspond to:

The previous chapter
The current chapter
The following chapter